Murder At Roissy

Murder At Roissy

by John Warren

a division of Greenery Press

© 1999 by John Warren.

All rights reserved. Except for brief passages quoted in newspaper, magazine, radio, television or Internet reviews, or images of the cover for purposes of review or publicity, no part of this book may be reproduced in any form or by any means, electronic or mechanical, including photocopying or recording or by information storage or retrieval system, without permission in writing from the Publisher.

Published in the United States by Greenery Press, 3739 Balboa Ave. #195, San Francisco, CA 94121.

E-mail: verdie@earthlink.net

http://www.bigrock.com/~greenery

ISBN 0-890159-01-8

This book is dedicated to Len Dworkin, a friend, a mentor and a role model for many in the scene. May he be where the great are no longer nibbled to death by the weak of spirit.

The author would like to acknowledge the unflagging devotion of his loving partner, Libby, without whom this could not have been accomplished.

1

SATURDAY. "How much longer until we get there, Sir?"
Sue asked in her "little girl voice."

Tom heaved an exaggerated sigh and said, "Fifteen min-
utes ago, it was half an hour. Unless you have managed to
repeal the laws of the universe and of mathematics, we should
be there in another 15 minutes."

Sue Burger twisted in her seatbelt and playfully began
hitting her husband on his shoulder with both of her petite
fists. "Now, now, now, I want to be there now," she chanted.

Tom looked over at her with a mixture of loving care and
paternal frustration, but was careful to keep one eye on the
road. Even on a arrow-straight, plumb-level Arizona highway,
things happened fast at eighty miles an hour.

She met his eye, gave him one of her blinding smiles, then
stuck her thumb in her mouth and crossed her eyes.

Tom laughed and turned back to the road. He reached over
and ran his fingers through her long silky hair and then rubbed
the back of her neck until she was making urgent mewing
noise.

"You're not making the waiting any easier, darling," she
gasped. "Unless, of course, you are interested in pulling over to
the side of the road and satisfying your horny wife right here
and now."

Tom pretended to study their surroundings. Then, he shook his head. "It must be at least a hundred degrees out there, and every rock is a scorpion hotel. We can wait until we get to Roissy. Besides, I'd get a sunburn."

"I wouldn't," Sue said thrusting a shapely, olive-skinned forearm into her husband's view and slowly rotating it so he could admire the flawless skin.

"I would," he countered.

Ten minutes later, they arrived at an unremarkable side road that led off into a range of low hills. The mailbox at the road junction said simply, "Roissy Resort, M. Flame, proprietress." The road in was unpaved but smooth, and they made good time for the two miles it took to arrive at a cluster of adobe buildings inside a thick wall. The gate was open, and several cars were parked against the back wall. Tom parked next to them. The instant the engine was shut off, and the air conditioner with it, the temperature in the car started to climb precipitously.

Tom unfastened his seatbelt and gave Sue a peck on the cheek which turned into a full-fledged kiss when she grabbed him by the hair and pulled him close. Soon, they were both gasping and pawing at each other, oblivious that the car was rapidly turning into an oven.

A discreet tap on the driver's side window brought them both shooting upright. Tom spun around and gasped. The face in the window was something unearthly, black and shiny. Sue's fingernails digging into his arm told him that she was seeing the same thing. Then, he relaxed and gave a quiet laugh when he realized that he was looking at a leather bondage mask.

Brown eyes looked out from behind the mask, which was fastened to the face with a series of leather straps secured with tiny silver locks. There seemed to be an opening for the mouth, but it was covered by a sheet of leather, with several perforations to allow breathing. Tom lowered the window, letting in a blast of heat. The voice from behind the mask was masculine but subservient.

2

"Mr. and Mrs. Burger? I'm Scum, the house slave; may I take your things to your room?"

Tom threw a switch on the dashboard that opened the trunk. Scum stood up and walked toward the back of the car. He was taller than he had seemed kneeling by the window and was dressed only in a leather posing strap. Weightlifter's muscles moved smoothly under a deeply tanned skin.

"Buy me that for Christmas, Daddy," Sue said dreamily.

"Well, I guess we are really here," Tom said. Then he caught sight of a short voluptuous woman in a red silk dress and riding boots, coming toward them. She had a riding crop in one hand, and as she passed the heavily laden Scum she gave him a playful whack on the backside.

She opened his door and extended her hand. "You must be the Burgers. I'm Mistress Flame; I own this place." She gestured with her left hand as she shook Tom's. "Let's get inside. In this country, even the lizards keep undercover until the sun goes down."

Sue opened her door and climbed out. Flame gave her a smile and herded both of them through a nearby door. The blast of air conditioning made them both shiver but was a welcome relief from the torrid outside air.

The room looked more like a doctor's or accountant's office than the reception area for a resort. The unadorned adobe walls were set off by massive beams, and a double-glazed window looked out into the courtyard. Behind a Swedish Modern desk, a massive cubist painting hung over a computer center. Flame led them to a conversational grouping around a glass and steel coffee table. She sat down in a leather-covered recliner and Tom and Sue sat on the comfortable, leather-covered sofa.

"I hope you had a nice ride from Phoenix," Flame said.

Tom nodded, but Sue seemed to be too busy looking around to respond.

"I'm sure you will enjoy it here. I know you have my brochures and we've talked on the phone a few times, but I'd

like to go over a few things just to make sure. I try to allow as much freedom as possible, but I've found that I need a few rules for things to run smoothly.

"Breakfast is served in the dining room from 8 to 11. Lunch is served from 11 to 2. Generally, we have a sit-down dinner at 7. Dress is optional, and I mean that seriously. You can eat or wander around in anything from a tux to your skin.

"We're on a first name or scene name basis here. You don't have to identify yourself any more than that. Do you have scene names, or will Tom and Sue do?"

Tom said, "Those are the names we use in the New York scene. They'll do here."

"There are only two other guests here, but we are expecting a few more soon. You may mix with the other guests as much or as little as you want. The basic rule is that everyone must consent. There are two dungeons. They have locks on the door. If you want to play by yourself, lock the door. If you don't lock it, anyone can assume that you will not object to observers, or to someone using the equipment that you are not using. However, if someone is playing in an unlocked dungeon and you would like to become part of their scene, wait for them to invite you. Asking during the scene is bad manners and can break up the rhythm.

"Your rooms also have some basic equipment, and I'll be glad to supply stuff like cuffs and rope if you haven't brought some of your own. Just ask me; don't take it out of the dungeon. I have extras.

"There isn't any bar here, and while I don't tell guests that they cannot drink or use drugs, I do have the option of barring anyone I consider unsafe from the dungeons, and if the situation persists, asking him or her to leave.

"Scum is the house slave; he is available to participate in your play, but not for sex. Check with me if you would like to use him. We'll talk over the scene you want to do and I'll be present during it."

"I've been thinking of switching," Sue said quietly. Tom gave her a good-natured "shut-up" glare.

As if on cue, Scum entered through an inside door. He walked over to Flame and knelt at her feet, pressing his forehead against her right boot; she idly ran her fingernails over the leather top of the mask.

Flame rose and gestured for Tom and Sue to follow her. Scum remained in his abject position. They went through the doorway from which he had entered.

One side of the hallway was thick, ceiling-to-waist-high tinted windows, providing a spectacular views of the surrounding countryside. The other side had doors at regular intervals. Flame opened the first such door. Inside, about a foot away, was another door that opened into a room.

"Completely soundproof," Flame said. "We want you to be able to get your sleep even if someone is playing."

The inside of the room was painted completely black except for a blood-red carpet. Flame flipped a series of switches against the door; red and white accent lights came on in the ceiling.

With a proud proprietary air, Flame walked around the room. "I'm sure you are familiar with most of this. If you need help, feel free to ask me or Scum. We have a set of stocks..." She ran her hand over the polished wood, "...a frame for standing bondage or suspension, a spanking bench, and even..." she smiled, running her hand over the long shelf and its winch "...a rack."

Sue fairly flew to the bondage frame and, grabbing a hanging chain in each hand, assumed the position of a woman about to be whipped. Looking back over her shoulder and wiggling her generous hips, she giggled and said, "I was soooo bad. Are you going to punish me, Sir? Are you going to punish me real hard?"

Tom walked over and gave her a quick swat on the behind., whereupon she whirled and pulled his head down for a passionate kiss.

5

Flame waited patiently until they came up for air and pointed at a polished wood plate with several keys hanging from brass cup hooks. "Every lock in this place has a spare key. The dot of color on the key corresponds with a dot of color on the lock." She picked up a length of chain with a padlock through it and indicated a colored dot near the keyhole. She removed the key from the padlock, took the corresponding key from the plate and demonstrated by locking and unlocking the padlock. Then, she returned the key to the plate and replaced the first key in the padlock. "Leave the keys in the locks when you are finished with them, but if one gets lost you can still unlock your submissive with the spare key.

"You can use your personal safewords if you wish, but the house safeword is 'Red Light.' If you use that, Missy," she said, impaling Sue with her gaze, "and he doesn't stop, everyone who hears it will come to help. So you just better damn well mean it."

Leading them out into the corridor, she said, "This hallway runs around three sides of the building. There is a second dungeon just like this on the other end. In the cross-over hallway, there is a common room and a dining room.

"Your room is here." She indicated a door several rooms away from the dungeon. Unlocking the door, she handed the keys to Tom. It was a large airy room with a small window looking out into the courtyard. Over the bed, a large mirror looked down from the ceiling. Sue spotted it and dove on to the bed. Rolling around in mock passion, she called out, "Don't blindfold me, Sir. I want to watch."

Flame showed Tom the eye bolts in the overhead beams and around the base of the bed, and explained how to adjust the very versatile chair that doubled as a bondage table. Finally, she showed him a small library of bondage and D&S videos on the bookshelf. "We don't get good television reception out here, and in any case, most of our guests aren't interested in watching the networks. So each TV has a VCR, and we have a fairly extensive selection of videos in the main office. If you'd like to

make a video record of yourselves, you can check out a video camera. We've got three, and they're available on a first-come first-served basis."

Tom was paying polite attention to her, but his gaze kept straying to Sue, who was continuing to admire herself in the overhead mirror. Flame glanced between the two of them, smiled and slipped out the door with a polite nod to Tom. She hadn't reached the door to her office before she heard the snap of the night lock in their door.

Scum was still kneeling by the chair in which she had been sitting, but instead of returning to it, Flame took her place behind the desk. "Front!" she said in a peremptory tone. Scum leaped to his feet, dashed over to the carpet in front of the desk and then dropped to his knees.

"Mr. and Mrs. Park will be coming in later this afternoon. Make sure that Room Seven is ready for them. Mrs. Park is particularly fond of roses; make sure there is a fresh bunch in the room every day. Also, as usual, she will be bringing along a bunch of computer equipment; move an extra desk into the room. Put it near a plug.

"Shawn and Kevin will be here late tonight. Wait up and show them to their room. Wake me after you've settled them and I'll tuck you in."

2

Later, Sue was lying next to Tom, touching only with the tips of the fingers of Tom's right hand against the tips of the fingers of her left hand, as the gentle breeze from the ceiling fan evaporated the thin film of sweat that covered both of them.

"You're magnificent," Sue said, meeting his eyes in the mirror overhead, "a great hairy animal." She gave a dramatic sigh. "What a shame the rest of the world has to put up with ordinary lovers while I have you all to myself." She rolled over

and, with the skill of long practice, nestled into the crook of his arm.

"You, too, darling," Tom said, still a little breathless.

Sue nibbled at his right ear, and he closed his eyes and rolled his head back. Her right hand began playing lightly with the skin of his balls, and the resting warrior twitched fitfully.

Tom reached down and gently but firmly took her right hand in his left. "Darling, I am forty-five years old, and I am not now nor I have I ever been a performer in Havana. You've got to give me a little time to rest."

Sue jerked her hand out of his and rolled off his arm. Facing away from him, she said, poutingly, "You don't love me any more. I don't turn you on."

Rolling over onto his side, Tom drew one fingernail down her back. She shivered and slid back a bit. Next, he put his fingernail against the back of her knee and drew it upward until it reached her ass. This time she moaned. Leaning forward, he touched her ear with his tongue and whispered, "Let's explore."

Sue fairly exploded out of bed. Spinning on the ball of one foot, she grabbed Tom's wrist and tried, unsuccessfully, to pull him out of bed. "The dungeon; let's look at the dungeon," she said happily.

Then, she pulled two fluffy terrycloth robes out of the closet and threw one at him. He got up, mimicking the exaggerated caution of the very old, and stood barring the door.

"Explore, yes. Dungeon, no. I'm tired; that's T, I, R, E, D, you little mink. We'll explore now."

"... and play later, Sir?" Sue said contritely.

"Yes, and play later," Tom said with a grin.

2

"Thank you, darling," Sara Stewart said to her husband of two days. "This place is wonderful."

"It's expensive, but it's worth it," her husband George conceded, from inside the bathroom where he was toweling off.

"Stop worrying about money for at least a few minutes," Sara said with a bit of an edge to her voice. "Virtuality is gone; we aren't rich any more, and I'm going to have to go to work to keep bread on the table, but we've planned this honeymoon for a year. It's all paid for, and there's nothing you can do about it."

Then, more playfully, she said, "If you don't stop moping around, I'm going to have to stop you myself."

"How do you plan to do that?" her new husband said, anticipation making his voice shaky. Then, he said, in awe, "Oh, my god."

Sara stood in the bathroom's doorway. She wore only a leather thong bodysuit. The nipples of her ice-cream scoop breasts were just visible at the top of the built-in underwire bra. The costume's high French cut combined with the five-inch heels she was wearing to give her a haughty and regal stance. In one hand, she held a chain dog-leash; in the other, a collar.

He let the towel he was using fall to the floor. "When did you change?" he asked.

"I've been telling you for months that you lose all track of time in the shower. I even had time to fix my makeup."

With a start, George realized that she was right. The subdued travel makeup was gone, and in its place, she had created a face that a goddess would envy. Subtle eyeliner and eyebrow pencil had made her dark eyes seem elongated and slightly slanted. Lipstick pencil outlined her lips which were luminous with a slightly lighter color. A delicate, sophisticated use of base and powder brought out her high cheekbones and drew the eye back to the vivacious eyes.

With long practice, he sank to his knees in front of her and bent his head forward so she could lock the collar around his neck. She fastened the leash to the collar and led him toward the door of the room. When he realized where he was going, a

9

wave of panic gripped him. He stopped, ignoring her tugs on
the leash.

She turned. One perfectly shaped eyebrow went up and
she asked, "Are you refusing?"

Once, white-water rafting, George had fallen out of the
boat and had been swept helplessly along for more than half a
mile before he was able to break free of the current. He felt
that wild disorientation again.

"You don't want me to walk out in the hallway – like
this?" he said, knowing the answer. He could feel the tiny
muscles in his scrotum trying to pull the bag up into his body
cavity, a primitive fear reaction.

"Of course," his wife said calmly. "We are going to the
dungeon. Don't you want to be properly dressed?"

Then, she took his head between her hands and said, "I
want you to."

George felt his resistance fade, and his erection begin to
grow.

The fear grew as he stood in the hallway while Sara locked
the door of their room behind them. He looked both ways in a
funk that any moment another guest might come by. Most
humiliating was the realization that, rather than going away,
his erection was getting larger and more painful.

The dungeon's door was less than forty feet from their
door, but to George, the walk was endless. He locked his eyes
on his wife's firm buttocks and willed himself to invisibility. It
was only when the dungeon door clicked behind them that he
relaxed.

"Did you lock it, Mistress?" he asked.

"No."

"Please."

"No, we aren't going to be using the entire dungeon," she
said calmly, setting up several candlesticks from the black bag
she had brought with her. "It wouldn't be fair to hog it –
besides, I don't mind someone watching. Should I call Mistress
Flame?"

George stared at the floor. He knew that he could object, and she would defer to his wishes, but he hoped that she wouldn't realize that having Mistress Flame watch didn't really bother him. It was the thought of another man seeing him so helpless that terrified and excited him.

She put a single wax taper into each candlestick and lit them with a disposable cigarette lighter. Then, she walked over to the control panel and turned off the white lights, leaving only the red accent lights burning.

Turning back to him, she smiled. "Lie down on the table," she said.

?

The door to the dungeon was unlocked, but as soon as Tom opened the first door, they both knew that it was in use. A low quavering moan came through the closed inner door. They exchanged a glance, and Tom shrugged. "Flame said that anyone who wanted privacy should lock the door," he said.

As he opened the second door, the first thing he saw was a blond woman who seemed to be wearing only high-heeled boots. She was facing away from the door and a glow of candle light came from in front of her. Only a few of the red accent lights were on, giving the dungeon an air of excitement and mystery.

?

Sara felt the door open behind her. George must have felt it too because he turned his blindfolded head toward the door. A bit irritated by the interruption and George's inattention, she moved the candles a bit closer to his skin and let three drops fall in rapid succession on to his left nipple. He gave

another of his lovely moans and his cock quivered and seemed to get a bit bigger.

When she turned to see who had entered, she was surprised to see a tall, handsome man and a short, spectacularly shaped Asian woman. She had thought that the intruders were either Mistress Flame or Scum. Then, she remembered that Mistress Flame had said several new arrivals were expected today.

The tall man settled on a bench and gave her a friendly wave while his companion flashed such an open, bright smile that Sara completely forgot about her irritation and returned it with enthusiasm.

Turning back to George, she drew a fingernail slowly along the length of his erect organ, causing it to quiver and George to arch his back to prolong her attentions. He hissed between his teeth as she lightly stroked the underside of the glans.

With her other hand, she picked up the red candle she had been using and noticed that a pool of melted wax had accumulated around the wick. In one smooth motion, she withdrew her hand from his cock and poured the hot wax directly on the shaft.

George gave an ear-splitting scream, jerked in a frenzy at the bonds that held him flat on the rack and ejaculated so violently that some of his semen struck the wall over his head. Then, he sank back on the padded bench, every muscle in his body limp.

Sara blew out the candle, unbuckled the straps that held her husband spread-eagled, and let him contract in a fetal position while she stroked his forehead. When she was certain that he was comfortable, she looked up at the newcomers.

They were sitting together on one of the benches. Her robe had fallen open, and he had his arm around her and was gently caressing her nipple. She had her eyes closed and was slowly rocking in ecstasy. He nodded politely again when he saw that Sara had looked around. He must have changed his

12

rhythm a bit or sent some other signal because a second later the young woman opened eyes and favored Sara with another smile.

The two of them stood and came over to where Sara was standing, still stroking George's forehead. The man extended his hand and said, "Hi, I'm Tom, and this is Sue. Flame said it was all right to come in if the door was unlocked. I hope we didn't interrupt anything."

"No, not at all," Sara responded. Then, she took the hand of the woman who said, "That was lovely. I wish we could have seen the whole thing." She closed her eyes and arched her back, making her breasts dance with the movement. "I love wax; Tom is just so good with it."

Tom waved his hand in deprecation. "From what I've seen, we'll have to exchange tips. I'd say there are some things you could teach me."

Sara put her back against the bench where George was lying and hopped up into a sitting position with her legs dangling over the side of the table. George moved slightly and she lifted his head and set it down on her lap. She could feel his even breathing against her belly through the thin leather of the body suit. She ran her fingers though his hair.

"Oh, no," she said, "I'm really new to this. George introduced me to it only a year ago. I was his secretary at Virtuality, the naughty boy."

Tom looked thoughtful. "Virtuality... where have I heard that name?"

Sue closed her eyes and recited quickly in a business-like monotone, "Virtuality, Stock code VTY, traded on NASDAQ, unfriendly takeover by Park, Inc., last month. Stock is down to around 17 from a high of 32 during the takeover. The company did research on programming of benign viruses." She opened her eyes and grinned at Tom. Her voice regained its "little girl quality" when she said, "We don't have any stock in them, Sir."

Sara was nonplussed. Sue had come across as an amiable bubble brain, but the information she quoted was precisely

correct. Sara had been reading the Wall Street Journal on the airplane, and Virtuality was holding steady at 17.1.

Tom laughed out loud. "Your expression is precious, but even people who meet Sue in more..." he waved his left hand in a short arc, "...conventional surroundings are surprised by what is in that cute little head." He ran his hand though Sue's long silky hair.

Sue looked at the floor and scuffed one foot, looking for all the world like a little girl embarrassed by adult attention. Then she looked up and said brightly but with an affected lisp. "I've got a photographic memory."

"You've got more than that," Tom said looking at her proudly. Turning back to Sara, he said, "Lots of people have a photographic memory, but they can't use the information they remember. My darling can put it to work. When I met her, I was a junk dealer."

"You were an office equipment reseller," Sue said, not a trace of little girl in her voice.

"Well, I am now. We have one of the biggest exchange operations in New York, and it's all due to my little girl right here."

Sara had been aware for a while that George was moving a bit. She put her finger to her lips, and gently rocked his head until she felt him wake up slightly. Quietly she said, "George, darling, I have some people I want you to meet."

He started to roll around to a sitting position and then she felt his muscles tighten and she realized that he had recalled his condition. Not letting go of him, she said, soothingly, "We've discussed this. You know how much you've wanted to do this. Show me how strong you are. Show me your courage. It turns me on so much."

She felt him relax a bit, but a red flush appeared under the blindfold and spread downward. She helped him into a sitting position and then took off the blindfold. Despite the dimness of the room, he blinked and then his eyes darted between Tom

and Sue. Then, he turned and looked at her, a kind of wild excitement in his eyes.

Tom solemnly extended his hand, but Sue, looking at George's crotch said, "That's so pretty; isn't it, Sir." Following her gaze, Sara had to admit that the multicolored waxes had created a lovely pattern on her husband's thighs and genitals, and to her surprise, while she looked at it, the cock began to twitch and become hard again.

George's eyes were darting around the room like a bird battering itself against the windows of a greenhouse, but Tom said loudly, "Pleased to meet you." Custom and habit took over, and George settled down and extended his hand.

"Your wife has introduced you, George," Tom said. "This refractory wench is my wife, Sue." Sue curtsied prettily.

Sara thought that it was unlikely that Sue was unaware of how the movement made her robe fall all the more open, and she was surprised not to feel any jealousy. Sue seemed like such a free spirit, without a shred of malice in her body. Besides, she thought with an internal grin, George wouldn't be interested in such an obviously submissive woman; his needs are at the opposite extreme.

George tried to say something, but the flush deepened and he just sputtered a bit. Before the situation became uncomfortable, Sue said, "It's a shame, all this nice stuff and nobody using it."

Tom's sparkling eyes met Sara's and he said softly, "Work, work, work." Taking one of Sue's hands in his, he led her over to the whipping frame. Sara was impressed with the speed and sureness he showed in working with unfamiliar equipment. In less than a minute, Sue's naked body was tied firmly, her arms over her head and her legs spread apart. Tom took a CD from his bag and slid it into the dungeon's stereo. The first few bars of one of the pieces from "Phantom of the Opera" filled the room as he picked up a multi-tailed whip.

2

Just after dark, a Lincoln towncar made its way through the gate and moved smoothly over the packed ground to the parking area. The door to Mistress Flame's office flew open and Scum came out at a trot, angling across the compound so he arrived at the passenger's door the instant the car crunched to a stop. In one practiced motion, he smoothly opened the door and bowed low.

"Mistress Flame has told me to welcome you to Roissy. Your regular room is ready."

The leg that first appeared from the darkness inside the car was flawless, with smooth musculature set off by a sheer stocking and a high-heeled sandal. Above it emerged a great mane of dark hair that parted as the woman stepped from the car to survey the surroundings. Her oval face was set off by a hairstyle that had the controlled casualness of a mountain river. She was wearing a black silk charmeuse gown cut on the bias so that flashes of those magnificent legs were intermittently visible. A velvet choker circled her neck.

Momentarily ignoring Scum, she turned away and lifted her arms and ran her hands through her hair, causing the muscles to shift and flow along her back. Then, she turned back and studied Scum as he stood passively holding the door. "Ah, Mistress Flame had told me that she had a new house slave," she said, her eyes appraising his body. She stepped closer and brought her hand around, slapping his face sharply. She made a skipping step back and watched him, her eyes blazing with emotion. "Did you like that? Did you? Did you?" she demanded.

Scum looked at her impassively and said, "If it pleases you, Mistress."

"Do you know who I am?" the woman asked.

"I have been told that you are to be addressed as Mistress Raven," Scum said. "I have not been told the name of your – companion."

"That's right; I'm Raven, a magnificent bird of prey." She spun on one foot, her hands over her head, breasts high. Only a slight stagger betrayed what might have been a touch of intoxication.

A stocky man in an expensive blue workshirt and Levis had emerged from the driver's side of the car and walked back to the trunk. "You, come here. Quit watching the floorshow and bring our stuff in," he said to Scum. Opening the trunk, he said, "Everything except the spare goes inside. Be especially careful of the blue case; it's full of electronics."

Raven skipped about the compound. "I just love it here. I'd like to move the whole headquarters to Phoenix so we wouldn't have to wait three months to come back." She spun back to the stocky man. "Let's do it. Shift everything to Phoenix. We can live here, and you can be my slave all the time."

Instead of responding, he effortlessly picked her up in his arms and carried her toward the door as Scum loaded himself down with suitcases.

"Oh, my strong slave, my big strong slave, carry me into the room where you can pleasure me all night," she said giggling. One of her shoes had come loose and she balanced it on her toe while she kicked up and down. As they were about the enter the door from which Scum had come out. It fell off, unheeded. The door closed behind them.

Scum, following behind, put down the suitcases and picked up the shoe. Looking furtively around to make sure he was unobserved, he undid the mouthpiece of his mask and spat directly into the shoe.

17

2

Several hours later, a Jeep Wagoneer came through the open gate. Two middle-aged men climbed out. "... and I told you it was a left at the watertower. If you weren't so sure of yourself, we would have gotten here before everyone was asleep. Now, we are going to have to wake up poor Mistress Flame, and it's all your fault," said the slightly built one with thinning straw-colored hair.

"Shawn, if you've tell me that once more, I'm going to forget what a lovable person you are and use the cane on your feet tonight," said the crew-cut redhead.

Immediately, Shawn threw himself on the ground and clutched Kevin's legs. "Please, please, me Master," he begged dramatically. "Please you be forgiving me." Then, he paused and cocked his head to steal a covert look at the Kevin's face. Both burst into laughter. Pointing at the hood of the car, Kevin said, "Assume the position."

"Shawn, right now?" Kevin said, his accent vanishing.

"Right now, and it will be another twenty for using my name when we are in scene."

"But truly can you say we were in scene?" Shawn protested.

"You're on your knees begging, aren't you? Another twenty."

Surrendering, Shawn got to his feet and bent over the Jeep's hood. "Can I keep my pants up?"

"Drop them!"

Shawn straightened up, did as he was told and resumed his position. Kevin opened the back of the Jeep and took out an old-fashioned razor strop.

The first stroke drew a howl from Shawn. Kevin bent over his partner. "If you have to make noise, damn it, count!"

"Yes, me Master. One, me Master. May I have another?"

18

The belt fell again. "Two, me Master. May I have another?"

2

Inside the main building, Scum was awakened by the Shawn's yell. "Damn," he said to himself. He had fallen asleep waiting for the two pansies. If Flame found out about it, there would be hell to pay. However, he thought, they seemed to have found a way to amuse themselves while waiting for him.

He watched them for a few minutes longer. Even under the mercury floodlights that flooded the compound and played havoc with colors, the little queer's backside was getting tomato red.

Adjusting his bondage mask, he stepped out the door.

20

2

SUNDAY. It was a bit after ten a.m. when George and Sara staggered to the dining room. Sara was wearing batik patterned lounging silk while George was attired in jeans and a sweatshirt; however, a leather collar with several metal rings announced his orientation.

Sue was sitting at one of the tables, nine tarot cards laid out before her in a cross, with another laid horizontally across the second from the top. As they approached the table, she picked up the third from the bottom, a colorfully dressed man with a plumed hat. "This is the six of pentangles," she said. "It's gratification."

Tom gave her a gentle pinch on the nipple and was rewarded with a quick kiss. "Yes, that kind, but you big hunk of man, you know you're going to get that. It also means success in legal matters or..." and she pointed to the coins and scales "...in taxes." She giggled and hugged him. "Maybe we can figure out how to deduct this trip."

She put down that card and picked up the next one, an upside down pope-like figure with two tonsured figures kneeling at his feet. She giggled. "This position is for the emotion card, your emotions. Normally, the Hierophant would mean repression... you know, 'male chauvinist pig' sort of stuff, but reversed, it's just letting me know that my darling Thomas is a

21

master among masters, the best dominant in the whole wide world." They shared another kiss.

Finally, she picked up the last card, a figure balanced on a rope holding two pentangles while a swan-headed boat sailed past in the background. She pursed her lips at this one. "This is the outcome card. There's some sort of change coming. It should be good but there will be a bit of confusion for a while. Maybe something will happen with ropes, or it may be allegorical, like 'knowing the ropes.' You're going to have to balance something, but with what I get from the rest of the reading, you should do fine." She touched his hand. "You always do anyway."

"Is that tarot?" Sara asked.

Sue nodded and said, "This is the Robin Wood deck. It combines the traditional card designs with some really nice natural symbolism. I've got a Mother Peace deck with me too." She flashed her gamin grin and added, "That's a bit way out for this. It has a lot of goddess imagery." She winked. "My women's group loves it."

"Could you do one for me... No, better yet, could you do one for George?"

Sue dimpled and said, "I'd be glad to. It there any particular question you'd like me to ask the cards?"

"You can get specific answers?" Sara asked.

"Well, the answers aren't always that specific," Sue grinned. "In fact, they can be damned cryptic sometimes. Let's just do a Celtic Cross. It's one of the most traditional forms. It gives you an idea of where you are and what's going on around you."

George's expression was a mix of skepticism and hunger. Sue shuffled the deck, handed it to him to cut, reshuffled and had him cut again. Then she said, "While I'm laying out the cross, why don't you two get something to eat?"

Sue repeated the pattern of seven down and three across while Sara got an incredible mound of fruit from an ice-lined trough and George got a stack of pancakes from a steam tray.

Each armed themselves with coffee and fruit juice and returned to the table where Tom had gotten up to free the seats next to his wife.

"It that a mango?" Sue exclaimed, pointing at Sara's hoard.

Following her eye, Sara used a spoon to extract a small orange-red half-sphere from the multicolored heap. Examining it as if it were a jewel she intended to buy, she said, "I believe it is; would you like one, darling?"

"Thank you; thank you, my lady," Sue said with a giggle. Instead of extending her hand, she put her hands behind her back, bent forward from the waist, opened her mouth and closed her eyes.

Sharing a grin with Tom, Sara popped the fruit into Sue's mouth.

Leaving her hands behind her back, Sue sucked on the fruit. A dribble of juice escaped her mouth and ran down her chin. Swallowing, she turned to Tom. "I'm sooo messy; how can you put up with me."

Giving him a bright gamin grin, she suggested, "Maybe you would like to clean me up, Sir." She lifted her face as if for a kiss. Tom bent down and with great solemnity licked the wayward juice from her chin.

"You missed a spot," said Sue, stepping back and rolling down the elasticized neckline of her peasant blouse. A drop of juice glistened on the olive upswell of her right breast. Tom removed it with a flick of his tongue while Sue closed her eyes and shuddered.

"Is Scum the cook, too?" she asked, an expression of vague distaste on her face.

"No," Sara said with a *moue*. "Mistress Flame has an old Mexican woman and her nephew come in each day to do the cooking. The woman is really very good," She lowered her voice to a conspiratorial level "... even if she thinks we are all damned."

"What?" said Sue bending forward.

23

"Yesterday, I was taking a walk, looking the place over, when I saw a fat old Indian woman out in back of the compound, pounding some corn on a stone. I didn't know anyone did that any more. I just said, 'Hello,' and she started backing up muttering in Spanish and fingering a big crucifix. Then, she turned tail and ran back in the building.

"I talked to Mistress Flame about it, and she said the old woman was the best cook for a hundred miles around, but she thinks we are a bunch of devil worshipers or something."

"Why does she work here then?"

"Simple, twice the salary she could get anywhere else and a promise she doesn't have to talk with any of us."

"And the nephew?"

Sara smiled, catlike. "Now he is a whole different kettle of Indian. I've seen him twice now. Nothing to talk to, but when he didn't think I was looking, he was staring at me like I was a steak and he'd been stranded in a vegetarian compound."

Sue grinned at Tom. "I bet the old lady has a problem keeping the kid in line."

"Well," Sara said slowly, "Flame said there hadn't been any complaints about him." She leaned back, putting her hands behind her neck and making her teacup breasts stand out in proud relief under the silk. "I sure wouldn't complain. He looked about nineteen and built like a brick wickiup."

Then she pointed at the cross of cards. "What does this tell you?"

Sue took the horizontal card off the card at the nexus of the cross. "We'll start with the person, the seeker."

Sara smiled, "That's George, right?"

Sue nodded and said, "This is the hermit." She lifted a card with a man carrying a lamp. "This is a character who is reclusive, but also has light. It's reversed so the meaning also is that you have some sort of problem that you're trying to withdraw from."

Sara gasped and looked at George who was nervously looking at Sue.

Sue then got the card that she had removed from over the hermit card. "This goes along with the hermit. It is the eight of swords." She showed them the card. It had a bound and blindfolded woman surrounded by naked swords. "This kind of represents a fear or some sort of nonconsensual bondage." Sue looked up and, catching the looks in George's and Sara's eyes, tried to lighten the mood with "Not our fun kind of bondage at all."

It didn't work. Both of them continued to look at her with a mixture of fear and wonderment.

Sue took the card from the top of the cross. "This one represents your state of mind. This is the two of wands." She showed them the card with a watching man holding a globe and a staff. "This represents a watch and wait mentality."

Then she took the card beneath the crossbar. It showed a man carrying a bundle of sticks. "This is the ten of wands. It indicates that whatever it is that is on your mind is just feeling like overload, too much."

"Jesus!" George sighed.

"The two cards flanking the seeker are the recent past and the near future." She took the one from the right. "This is the ten of cups. In this position, it represents the recent past and would traditionally mean a new relationship, marriage or something like that." Sue looked up, positively glowing. "I just remembered you told me in the dungeon you had just gotten married!"

Sara, eyes wide, nodded and then kissed George.

Sue took the card from the right. It showed a man looking outward surrounded with several vertical sticks. "This indicates that 'your ship is coming in.' There will probably be some good news or an opportunity, but you have to take the advice of those close to you." She lifted the ten of cups. "Probably from the people represented by this card."

George's face fell a bit. "I'm afraid my ship sailed already. Hell, it's fucking sunk."

Sue stroked the card. "These are only indications but don't forget that people don't just have one ship. The cards are telling you not to give up."

Sara reached over and gave her man a supportive hug, which earned her a wan but manful smile.

Sue waved her hand over the top of the cross. "These five cards represent where you are now." She then waved over the bottom four. "These are more action oriented."

She picked up the fourth from the bottom, a man holding a scale and handing out golden coins to outstretched hands. "This is the six of pentangles. Like I was telling Tom a few minutes ago, this symbolizes success with legal or financial problems."

George's face showed just how much he believed that.

"The next card is your environment, family, friends, coworkers. This one is the five of pentangles. It isn't good news."

George looked at the card showing a one-legged beggar standing outside a church window surrounded by snow. "I can guess," he muttered.

Sue struck a brave smile. "Well, it does sort of indicate you won't be getting much help from outside your immediate circle. You are either going to get it from someone close to you..."

This time Sara's hug was intense.

"...or from someone you've hired, like an accountant or detective."

Sue picked up the second to the bottom card. "This position is for your emotions. It's the empress, a very positive card, which implies protection, fulfillment and happiness."

"The last card is outcome. In this case we have the four of wands. It's a card of celebration. It's all about the happiness of family life. Your security and happiness is destined to come from your family."

George shook his head. "You were incredibly close." He gave Sara a hug. Her voice was a bit muffled because she had

26

pushed her face against his chest.

"He's just a bit worried. He'll be back on top soon, but for the moment, we're watching our pennies. We couldn't have even come on this honeymoon except that it was paid for before George lost his company."

George grunted. "Five years plowing every cent back into more R&D. Five years of fourteen-hour days, and what did it get me? A hundred thousand dollars and a security guard standing over me to make sure that I didn't take any of the company pencils."

Tom looked at Sue in confusion. She shrugged her shoulder and raised her eyebrows, but her hand reached out under the table and gave his a squeeze.

Without letting go of George, Sara leaned back and said, "It's past. They could take the company, but they can't take your brains. We'll be back on top, and this time we won't make the mistakes we made last time. The cards were right about that."

"I only made one mistake. I listened to that damn lawyer. 'Take the company public. We need the capital.' I would have been better off borrowing it from the Mafia."

He cut off a piece of pancake as if he were carving open a lawyer's heart.

Before anyone else could speak, Sue turned to Sara and said, brightly, "This is our first time here, too. It's a special vacation. We've been together five years."

"That's great," Sara said, shifting her chair so it was square with the table but keeping one hand on George's thigh. "This is such a special place."

"It should be, at $1,000 a day," George muttered without looking up.

Sara ignored him and went on. "George introduced me to domination and submission. I had always had fantasies, but I had been terrified to try anything. I mean, how do you tell someone you'd like to whip them?"

Tom and Sue looked at each other and shared a brief grin.

27

"Anyway, you can imagine my shock when my I'm-in-control boss admitted that he'd like me to spank him."

George put down his fork and took Sara's hand from his thigh and solemnly kissed her palm, then, for the first time, looked up. "I was scared to death," he said with the hint of a smile. "I knew there was a good chance I would lose the best secretary I had ever had, but I just had to do it."

He kissed her. "I couldn't sleep at night dreaming about her." The smile became a little more obvious. "Despite everything, I've managed to hang on to the one thing that means the most to me."

Sara gave him a radiant smile and turned to Sue. "How did you meet Tom?"

"He pulled me into an alley, ripped my clothes off, and I raped him."

Tom looked at her in exasperation. "Someday, someone is going to believe you." He turned to Sara. "We met at a club. Have you ever heard of The Dungeon?"

Sara nodded, her eyes wide. "Someday, we're going to fly to the East Coast and visit there and Spankers. There really aren't any places like those where we live, and even if there were, we couldn't take the chance that someone would recognize us."

Tom went on. "It was a private party for an AIDS support group. I saw her there and stalked her all evening."

"Until I caught you!" Sue interrupted, bouncing up and down in her chair. She leaned across the table to Sara. "He was so sexy in his tight little black jeans and a leather overshirt. I just wanted to run my hands over all that leather."

"I recall you were more interested in running your hands over my jeans," Tom continued.

The three of them laughed. After a moment, George joined in.

At that moment, Raven entered the dining room wearing a black unitard with a loose belt of gold mesh around her waist and a wide black ribbon around her throat. George saw her first

and was thunderstruck. His fork dropped unheeded to his plate and his jaw fell open. Sara heard the clatter, looked at him and then followed his eyes to the figure in the doorway. Her eyes narrowed, the tendons in the throat tensed and her hands formed fists.

Both Tom and Sue, seeing the change in their new friends, spun around in their chairs curious to find the cause.

Raven, who had just entered the room, gave a small wave and walked to their table. Jauntily, she said, "Hi, I'm Raven. Loki and I just got in last night."

Before she could say more, George sprang to his feet, knocking his chair back onto the floor. His eyes blazing, he almost ran out of the room.

Sara stood up but held her ground. Raven looked confused by their reaction while Tom and Sue were faced with the insoluble dilemma of trying to look in two opposite directions at the same time.

"I know who you are, 'Ruthless' Park, Sara said, her voice cold and measured. "Raven. What a fucking joke; you're not a raven; you're a fucking vulture. You make your living ripping apart companies better people have spent their lives building." She walked around the table and left the room.

Tom and Sue remained seated, obviously unsure of what to do next. Raven walked around the table and sat in Sara's abandoned chair. Scum had come into the dining room, probably attracted by the crash of George's chair. Raven waved at him and yelled, a bit too loudly, "Scum, get over here and take away these dishes and bring me some French toast and papaya juice."

While he was clearing away the dishes, Raven looked at Tom and Sue, a small half smile warring with a twitching muscle on her temple. "I like to make dramatic entrances, but that was overdoing it a bit. Like I said, I'm Raven."

Tom shook himself out of a daze and said, "I'm Tom; this is my wife, Sue." He extended his hand across the table. "Hi, Sue," Raven said after shaking Tom's hand.

29

"Hi," said Sue with an uncharacteristic lack of enthusiasm.

"You said you were here with Loki," Tom said. "Will he be joining us for breakfast?"

"I don't think so. I was pretty hard on the poor dear last night. He's sleeping in.... I guess you are wondering what all *that* was about," Raven said.

"Curious, yes, but it isn't any of our business. I suppose it doesn't have anything to do with the scene."

"No, I didn't even know they were in the scene. I certainly didn't expect to see them here. If I had known, I would have postponed my visit. It makes things – uncomfortable."

"You're right. This isn't the biggest community. It's kind of hard to get lost in the crowd."

"Well, I'm here now, and I'll be damned if I'm going to leave. If they want to leave, they can. I'm staying, and I'm going to have a good time," Raven said with finality.

Then, Raven noticed the cards that Sue was putting back in their box. "You do tarot? Could you please do one from me?"

Tom could see the reluctance in Sue's face and he was about to make an excuse, when she said, "I'm a bit tired out. I just did two readings; how about a five-card?"

Raven pouted. Clearly, she wasn't used to having anything less than all of her desires satisfied, and it was with poor grace that she said, "OK, if that's all you can do now."

Sue went back through the shuffle, cut, shuffle, cut routine again and laid out five cards in a row. The first was a scowling figure in ecclesiastical garb crouched within a parapet, the second an equally unhappy-looking man sitting a the base of a tree with three cups arrayed before him and a fourth floating unsupported in the air next to him, the third was a happier-looking young woman holding a golden disk imprinted with a pentangle, the fourth, a recumbent figure lying in a pool of blood pierced with a multitude of swords. The fifth was inverted and showed two naked figures, a man and a woman, pulling a treasure chest secured by heavy chains toward a distant doorway.

Surveying the cards, Sue's demeanor made a marked change from her lighthearted approach of a few minutes before. With a forced smile, she said, "You know, every once in a while a reading just goes off into the blue. I can't really explain it, but I don't think there is much here."

Raven was not to be put off. "Something bad, isn't it? Go ahead," she said in a strained voice and then lightened it and added, "Beside, I don't really believe this... much."

Sue took a deep breath and started. "There is an undercurrent of greed and mistrust here. The four of cups..." She pointed to the man under the tree. "... indicates you an in an ebb phase of your natural ebb and flow. The page of pentangles..." She touched the woman with the golden disk. "...indicates you either had a secure upbringing or that you should listen to your child within. I'd say the other cards are saying you should be cautious and make some changes soon."

Sue took a deep breath and essayed a smile. "Of course, this could all be just an anomaly. Things can get pretty funky sometimes."

Raven's face had gotten harder and whiter as Sue had gone through the explanation but now she stood up, a bit too fast and jerkily. "Thanks, dear, that was fun, but my tummy is simply crying out." She turned toward the buffet. "Now, what do we have today?" she said, taking a plate in a trembling hand.

Sue quickly gathered up her cards without bothering to put them in their boxes. She looked appealingly at Tom and they both quietly retired as Raven made her breakfast selection.

7

Back in the room, Tom turned to Sue. "You were uncharacteristically quiet in there. Is there something you know that you'd like to tell me?"

31

Sue sat down in the room's armchair so bonelessly it was almost like a fall. Her voice was the same dull monotone she had used the previous day in the dungeon. "Ruth 'Ruthless' Park, President and CEO of Park, Inc., has a reputation for remorseless, some say underhanded, dealing. There was an article about her with some pictures in last year's *Fortune*. It's her, no doubt. Park, Inc., took over George's Virtuality last month."

Tom frowned. "I think we can guess that George doesn't feel a lot of love for Park."

Sue looked at him, her face serious. "I think he may not exactly love her, but Sara looked like she wanted to pluck Raven's pin feathers one at a time. That woman can really hate. But what really scares me was the reading."

Tom nodded. "It was pretty bad."

Sue looked at him with a frightened look in her eyes. "I didn't give her the full meaning."

Tom laughed nervously. "It was worse?"

Sue nodded. "We had the four of pentangles, the four of cups, the page of pentangles, the ten of swords and the devil reversed. That was the most negative reading I've seen in a while. It kind of unnerved me. The implied question seems to be where will all this greed and avarice lead other than a small, unhappy world for herself. The recent-past card four of cups, which I told her was an ebb phase, can also be interpreted as a decline or oncoming darkness... creepy stuff.

"The only really good card was the one representing her, the page. It indicates she has the stuff to ride out this ebb period. What really scared me was the environment card. The ten of swords is called 'the ruin card'."

"I'll guess that's not a good sign," Tom said, laughing nervously.

There was no laughter in Sue's eyes as she nodded agreement. "It's an indication that your family, friends, co-workers, people like that are stabbing you in the back. This is really bad all by itself, but the answer card was the devil..." She inhaled,

32

shakily "... reversed! The devil by itself is a warning to the seeker about temptation. When it is reversed it is even stronger. It can show the unbalanced mind of a depraved person, or that the actions of a depraved person may harm the seeker."

Sue's inhaled breath was shaky. She looked at Tom, took his hand and said, "I'm so glad I'm not Ruth Park."

7

"God damn, son-of-a-bitch." George kicked the room's heavy armchair. It barely moved, but an expression of pain crossed his face. He fell backwards into a chair and massaged his slipper-covered foot. "Why the fuck did she have to show up here, right now?"

Sara sat down in the armchair, a thoughtful expression on her face. She seemed to be looking into the middle distance.

"'Let's go anyway,' you said. 'We've already spent the money,' you said. 'Let's have a good time and forget about Park's fucking underhanded dealings,' you said. Now look at us. We're trapped on this damned S&M Gilligan's Island with that female shark." His voice had risen until he was almost shouting.

By contrast, Sara's response was almost inaudible. "Dear, I didn't know she would be here. Don't you think if I did, I would have had us stay away?"

"I don't know about staying away," George shouted, "but we sure as hell are going away." He jumped up and threw a suitcase on the bed. "I'm not going to stay within a hundred miles of that bitch."

Sara stood up and with remarkable strength pulled George away from the bed. "Listen to me for a while. Have I ever led you wrong?" She paused, weighing the risks inherent in her next words. "When LeBow wanted to take the company public, didn't I advise against it?"

George flinched a bit but dropped his eyes and nodded.

"Here is what I've thought of." She pushed him into the chair and kneeled at his feet. "All of us are here, right? She can't get any further from us than we can from her?" George nodded but his eyes remained dull. Sara ran her fingers over his knee. "Well, she's pretty much taken everything from us..." George nodded again. "... so there isn't anything she can do to us unless we let her." She smiled a feral smile. "But if we really think about it, I'll bet there is plenty we can do to her."

George looked up for the first time in the conversation. As he looked at his pretty wife, a smile appeared at the corner of his mouth.

7

Despite her carefully prepared makeup, Raven's skin looked flushed as she paced up and down in her room, combing the strands of a whip through her fingers. "Why the hell did those two have to show up here of all places?"

Clayton sat on the side of the bed, looking concerned. "Maybe they'll leave," he said.

"Not goddamn likely. I'd say it's either we leave or we ignore them." She stopped and fired a challenging stare at Clayton. Then, she threw the whip against the wall. "And I'll be fucked if I'm going to be driven out of here."

He flinched as the whip hit the wall, but stood and put his arms around his wife. "Let's go to the common room and watch some television. Then, maybe we can do a little playing later. I'll let you whip me in the dungeon."

When Clayton first took hold of her, Raven was stiff with tension. As he spoke to her, she put her arms around his neck and melted into him with a sigh. "You'd do that for me?" she said.

"We've got to keep up your image as a hard-as-nails dominant," he replied. "Besides, I like it once in a while. Just not as a steady diet."

Raven licked her lips and said, "OK, but first I need to get a little fortification."

Clayton's face hardened as she pulled away from him, took a glass vial half full of a white powder from the dresser and scooped out a tiny amount of the contents with a small spoon. "I wish you'd lay off that shit," he said with frustration as she held the spoon to one nostril and sniffed. "I'm not going to play with you while you're high."

Raven put the vial back in the drawer and then spun across the room in a series of pirouettes, her laugh tinkling. "Don't be a stick-in-the-mud." When Clayton didn't answer, she stopped and began a series of ballet exercises. "All right, we won't play this morning; I'll be a good little girl and we can watch some dirty movies."

7

"That *bitch* is here?" Shawn said to Sue.

Tom and Sue exchanged glances at the violence of the outburst. They had thought they were just sharing a juicy tidbit with their new acquaintances.

"You know her?" she said quietly.

The resulting outburst began, "She's got the soul of a Killarney Protestant. It's as black as the pit and stinks of blood," but became almost totally incoherent, except as the passion rose it became completely free of any trace of Irish accent. Finally, Shawn leaped to his feet, kicked a side table and stormed out of the lounge.

In the silence that followed, Tom and Sue turned to Kevin in expectant silence. His face was a mixture of dread and concern.

Mostly to himself he muttered, "It's going to be a long week." Then, composing himself with a visible effort he essayed a weak smile.

"Shawn doesn't like her."

Sue couldn't help herself. The laugh simply exploded before she could do anything about it.

Rather than being offended, Shawn looked embarrassed. "Well, maybe that was an understatement. Still, he has a reason; she tried to break us up."

Tom's face was carefully blank, but Sue's resembled that of a cat smelling fresh meat. Lifting her knees, she wrapped her arms around them and tilted her head. "Do tell."

"Not much of a story. I was foolish. You know, thinking with my balls. It took me a while to wise up. I did, but Shawn is sensitive about the whole thing.

"It was about five years ago. It was a hard time for us. I was very confused. She's very attractive, you know," he said, looking at Sue for confirmation. "It's hard to admit, but all that money helped too." His eyes dropped. "It was nice going places that I'd only heard of. Being with her opened a lot of doors that a scholarship student from a state college couldn't get near before."

"What eventually happened?" Tom asked quietly.

Kevin looked actively miserable. "She wanted more and more of my time. I thought I could manage it, but eventually, I realized I had to choose." He shrugged. "She didn't make it easy. Then, when I chose Shawn, she got spiteful. She locked every door she had opened. She told people I was unstable, dangerous. She even had me fired from my job."

"Shawn and I have been together since then, but it hasn't been the same. It shook his confidence. I think he still wonders if I love him. We had some terrible arguments. I don't know if you can understand how my having desires for a woman threatens him."

Sue nodded. "I'm bi and I know how some lesbians react to that. It's particularly hard because I see myself as primarily a lesbian." She took and squeezed her husband's hand. "Tom is an exception," she said. "Still, there are a lot of women who feel that somehow I'm not a real lesbian."

36

Shawn returned her nod. "He's good about it, but I know it hurts him... and his not talking about it makes things even harder."

Sue unwound and slid across the couch to give him a hug. "I guess he doesn't realize how lucky he is," she said. "Maybe we can talk Flame into getting her to leave."

"We don't have to get Flame to kick her out. I've got an idea," Sara said, who had been quietly standing by the door listing.

7

Despite an air conditioner turned up until its roar filled the room, Tom and Sue were covered with sweat. Sue reached out her hand and after a bit of fumbling grasped Tom's. "That was good, Sir," she said between great mouthfuls of air. "Can we do it again?"

When Tom turned his head to look at his wife, his eyes met hers, that sparkled with unrepressed humor. "Woman," he said, levering himself up on one elbow, "thy name is lechery." He fell back on the bed with a finality. "Get thee to a nunnery."

Sue sat up and turned so that she was straddling one of his legs, leaning forward, her breasts providing a feast for his eyes. "That might not be a bad idea, Sir. You know that when Shakespeare mentions nunnery he is using an Elizabethan term for a house of ..."

With a resigned sigh, Tom grabbed her arms, pulled her down to him and silenced the literature lecture with a kiss. A few seconds later, he pushed her aside and dragged himself off the bed. "Come on, you Energizer bunny. I can see there is only one way that I'm going to get any rest." He led her out the door and down the hall to the dungeon. No one was in it. With practiced ease, he positioned her on the bondage table and put cuffs on her wrists and ankles. Then he fastened several heavy

straps to hold her motionless, finishing by putting a heavy leather, fur-lined blindfold over her eyes.

"Now, maybe I can get some rest. I'll be back in half a hour."

7

Raven looked up at the acoustical tile ceiling and tried to count the number of dots in each square. Beside her, Clayton leaned forward watching a video where a busty German woman was being tortured with a variety of needles and clamps. *He's got an appetite for this shit,* she thought, inhaling a bit more of the white powder from the vial. *I can only look at it so much and then I want to do it.* She considered enticing him down to the dungeon for a bit of private play, but realized that he wasn't the one she wanted to play with.

Clayton barely looked up when she stood and walked around the sofa. Raven bent close to his ear and whispered, "Enjoy the movie, dear. I'm going to wander around a bit." At that moment, the woman on the screen screamed, "Nein, Bitte!" in response to an obscene indignity, and Clayton redoubled his attention.

First, Raven walked back down the hallway to the dining room. Sara Stewart was no longer in the room, and the two thin men were finishing their breakfast alone. Suddenly, she recognized first Kevin and then Shawn. All thought of about joining them and trying to promote a threesome vanished and she ducked back around the door frame.

Leaning her head against the wall, she moaned. "Shit, why?" Dramatically looking toward the ceiling she said, "You have a fucking sick sense of humor."

Clayton was so entranced by his video he didn't see her glance in. She thought about telling him about who else was here but decided against it. Turning down the hallway to

38

Raven's office, she thought. *I'm going to play now if it kills me. Damn, why did all these bastards have to show up now?*

Maybe Scum is in the office. Looks like a bit of wimp, but he's better than nothing, she thought. The pretty boys like to show off, but they can't take what I want to dish out.

As she passed the dungeon, she tried the doorknob. It was open. When she opened the inner door, she saw the Oriental woman who had done that awful card reading for her spread-eagled on a table like a sacrifice awaiting the knife. Raven looked about the room. No one else was present. An open toy bag lay open on a table. She went over to it, admiring a length of rope made up of red, black and white cords. She put it on the table and took out a few other toys, not noticing as the end of the rope fell behind the table, dragging the rest with it.

7

Sue struggled against the bonds. She loved/hated this, locked in a universe of darkness with her mind playing tricks to her. There was no discomfort. In fact, the padded bench and the wool-lined cuffs were quite comfortable, but without sensory input, she could imagine fantasy fingers and lips until they seemed real. Time played tricks on her, speeding up and slowing down unexpectedly. The excitement built. She could feel the juices flowing down her inner thighs.

Master had said half an hour; surely it had been that by now.

A random gust of air blew across her body. She thought it might have come from the dungeon's door being opened and closed, but she couldn't be sure. Every fiber of her attention was concentrating for another clue. Then, unmistakably, a warm breath of air touched her breast. Someone was bending over her, studying her body. Was it Tom?

"Darling," she said tentatively, both hopeful and afraid. No response came. Then, something wet and soft, a tongue,

touched her left nipple. She arched and gasped. It withdrew, but the smoldering fires had been set aflame. Without her volition, Sue felt her hips moving as much as the strict bondage allowed. The tongue returned and she arched to meet it, but this time, it was joined by cruel teeth that clamped on the delicate nipple, sending waves of mixed agony and ecstasy through her.

Finally, the nipple was released and she felt the breath on her ear. An unfamiliar woman's voice said, "What a delightful morsel you are." Sue felt the passion drain from her body. "Who are you?" she said, her voice uneven. "Is Tom there?"

"I'm Raven the Cruel, and you are all mine."

"Tom! My God, Tom!" Sue yelled. Hearing no answer, she called, "Red Light! Red Light!"

"No fair, little one. I haven't even gotten started yet. You can't call a safeword on me."

Sue opened her mouth to scream louder, but a leather covered ball was thrust inside and a strap was fastened around her head to prevent her from spitting it out. She screamed, but the gag muffled the sound until it was indistinguishable from the mewing of an unfed kitten.

Fire kissed her thighs. Without the trust inherent in a relationship, the pain remained just that. With a stranger holding the whip, there was no way she could convert the pain into pleasure. The whip strokes moved up her body until she was dazed with pain. Then she heard a shout.

7

Tom looked at his watch. It had been twenty minutes since he had left Sue tied up in the dungeon next door. He picked up the heavy AC-powered vibrator and went out into the hallway. To his surprise, the outer door of the dungeon was ajar. He distinctly remembered closing both doors firmly.

40

Opening the inner door, he saw a woman in a black unitard standing over Sue. As he watched, she lifted a heavy cat for another stroke.

"What in the hell do you think you are doing?" he yelled and was across the dungeon in three quick strides, plucking the whip from the woman's hand. He roughly pushed her to one side, scarcely noticing as she stumbled and fell to the floor. Working as quickly as he could, his fingers clumsy with rage, he freed Sue and removed the gag. She wrapped her arms around his neck and sobbed on his chest.

Holding her close, he turned and examined the woman on the floor. It was the one who called herself Raven and who Sara had identified as Ruth Park. She remained on the floor, supporting herself with one arm as she stared at him with eyes filled with hate... and something else.

"Who in the hell do you think you are?" he yelled. "Sue sure as hell didn't consent to doing any scenes with you. If you've hurt her, I'll kill you, you crazy bitch."

The "something else" pushed out the hatred from Raven's eyes and she struggled to her feet. Brushing back her hair with one hand, she tilted her head back and met Tom's gaze directly. "I am Raven. I go where I want, and I do what I want. You don't have any authority over me."

"Maybe I don't, but when I talk to Flame, we'll see what happens. Now, get out of here before I break your goddamn neck," Tom roared while Sue tried to control her tears.

As Raven turned to leave, she saw something on the floor and bent to pick it up. Tom's foot was there ahead of her, pinning the small vial to the floor. "What's this?" he said, reaching down and picking up the bottle. He wet a finger and upended it against the wet skin. A few crystals of the powder adhered to the skin. Tom tasted them and made a face.

"Phew, angel dust. I would have pegged you for something classier like cocaine. Like to slum a bit?"

Raven started to extend a hand; then, withdrew it. Locking eyes with Tom again, she said, "It isn't mine. I just saw it

on the floor. It probably belongs to the chink slut."

Tom face went red. He thrust Sue away from him and drew back his fist. Raven stood unmoving, her eyes challenging and defiant.

"Tom, don't!" Sue screamed and grabbed his arm.

Raven took advantage of the distraction to slide out of the dungeon. She tried to slam the inner door but the automatic closing mechanism defeated her effort. She succeeded in slamming the outer door, but neither Tom nor Sue were listening.

"Hold me, just hold me," Sue begged, pulling Tom close again. She closed her eyes and burrowed into his chest.

7

Raven charged into the common room. Clayton was still watching a video. "Clayton, I'm sick of this fucking place," she yelled.

Clayton looked up "What's the matter, Ruth? You've always loved it here," he said without rising.

"Come back to the room, now!" she said, turning on her heel and striding out the door. Clayton slowly got up, extracted the videotape, turned off both the television and the player, and returning the tape to its place on the shelf. Then, he walked toward the door, a look of grim determination on his face.

When he arrived at the room, Raven was lying on the double bed, hugging a pillow.

"That bastard, George Stewart, he's got everyone turned against me. There's nobody to play with."

"What about me?" Clayton said.

"You, you? I've always got you. I wanted some ..." Ruth paused and quickly looked up at Clayton, her eyes wide.

Clayton turned off the overhead light. The windows were efficiently blocked by black-out curtains, and the only other light came from a single bedside lamp. Its lone bulb cast shad-

42

ows that made his face look cold and cruel. Raven, still clutching the pillow, shrank back.

Stopping at the foot of the bed, he stood silently, looking at her. Then, he bent down and slid a black leather gym bag from under the bed. "I think it is school time," he said.

Raven's long manicured fingers played with the pillow, kneading it and twisting it, but her eyes, locked on his, filled with a hard, desperate glitter.

Extracted a heavy, multi-stranded whip from the bag and holding it in his right hand, he ran his fingers through the strands and said, "I think you need a lesson."

Raven threw the pillow to one side and ran her fingers through her hair in a motion that reprised what Clayton was doing with the whip. "Clayton, I don't want to," she said in a soft and quavering voice, but her glance drifted down to the whip and she ran a tongue over her lips.

"Clayton? Clayton? I'm not Clayton, am I?" he said in a voice made harsh with desire.

"Loki, my master," Raven said, holding herself up with one hand and rubbing her covered breast with the other.

"Yes, Raven, I am Loki, and you are my slave. You've behaved very poorly today, haven't you?" Clayton said, the oblique lighting revealing a growing bulge in the satin boxer shorts he was wearing under his print robe.

"I have, Master; please whip me," Raven said, pinching her nipple through the cloth.

"Strip, Slave," Clayton said harshly.

Raven slid off the bed and moved over to stand next to the single light.

Teasing her upper lip a bit with her teeth, she put her hands on her hips and ran them up the front of her body until she was cupping her breasts, offering them to him. Then, she ran her fingers through her mane of dark hair, allowing it to fall back over her face and then spreading it with two fingers from each hand so she looked like some fierce beast peering out from the jungle.

Pushing the hair behind her, she snapped open the goldtone belt, catching it in her right hand as it fell from her hips. Raising her left hand straight over her head, she brought the belt around in a wide arc so it struck soundly across her back. She gasped and threw her head back. Then, she discarded the belt and combed her fingers through her hair again.

Her hips moving slowly to unheard music, she turned her back on him and slid the top of the unitard down over her shoulders to her waist. Her tempo increased as she slid out of the unitard completely and used it like a fan dancer's fan to tantalize and tease him as he leaned against the wall watching her. Finally, throwing it aside, she stood, motionlessly, for a moment arms akimbo and legs apart.

Slowly, with a measured progression, like a Bob Fosse-trained dancer, she began hip and pelvic thrusts as her fingers made gentle love to the exposed skin of her upper body and thighs. The lowest portion of her red panties had acquired a deeper, blood-like hue with the excitement dampening the fabric.

She picked up and wrapped the unitard around her neck over the black velvet choker, looked directly at Clayton with hooded eyes and ran her fingers over the discolored panties. Then, like a child with a bowl of leftover frosting, put one finger after the other into her mouth, sucking them dry. Closing her eyes, she again stood motionless and slowly undid the unitard from around her neck. She pulled one end and slid it slowly off.

Then, clad only in panties and the choker, she picked up the pace, her body flitting about the space between the chair and the lamp like a butterfly on its mating flight. Suddenly, she stopped facing the wall; her left hand went up to support herself as she leaned against it while her right hand teased the panties off her firm ass, an ass that was marked by old bruises and a pattern of fading red lines.

When the panties were free, she allowed them to fall to the floor. Putting her right hand next to her left on the wall,

Raven did a series of posing exercises that caused muscles to writhe under her skin like lust-crazed snakes. Clayton ran his tongue over his lips as he watched silently.

Finally, she turned and walked toward him, hands crossed in front of her and eyes downcast. Dropping to her knees at his feet, she removed the black choker. The skin under it was as puffy and reddened as that of her ass.

"The chair." Clayton said, in a passion-choked voice, pointing to the upholstered easy chair in the corner of the room.

Hips swaying, Raven stood and walked over to the chair, knelt in front of it and bent down onto the seat.

Clayton stood behind her and ran his left hand across her exposed pubis. Rubbing his fingers together, he commented in a severe voice, "You aren't wasting any time, are you? You're already dripping."

"No, Master," responded Raven, her voice muffled by the back of the chair.

"I think twenty would be a good number to start with."

"Yes, Master." Raven's voice had a odd mixture of exhilaration and resignation.

Standing to one side of her, he brought the heavy whip around into her ass. Raven gave a muffled cry and jumped a bit. The knuckles of her hands which were gripping the back of the chair whitened.

"One," he said, and brought the whip around for another stroke.

7

Mistress Flame brought her foot back, placed it in the middle of the kneeling Scum's chest and pushed hard. Surprised, he fell back into the middle of the room and made no attempt to rise. "You know I want to be informed immediately about any friction between the guests. They're paying me a

hell of a lot of money to have a good time. If anything is going to interfere with that I want to know immediately."

"Mistress, please, I came to you as soon as I realized it was serious. I didn't realize what had happened at breakfast was important until now. It was only when I talked to Master Tom in the hall a few minutes ago. He said he was going to come to see you soon so I thought you would want to know."

Flame accompanying her words with strokes from the riding crop she had in her hand, she said, "Everything..." Whack. "... that happens in this place..." Whack. "... is my business." Whack.

She knew the blows were so gentle that Scum had hardly felt them. The intensity of the punishment was unimportant, but she recognized that it was important to maintain the psychodrama that was part of their relationship. *Actually,* she thought, *Scum did quite well spotting the building friction between Stewart and Black and Park, and this latest blowup between Park and Tom is... unfortunate.*

She thought, I really should have returned George's prepayment when he asked. It must be quite a shock to have your company jerked out from under you like that. No... She shook her head ... *when I first started out more than half of the customers didn't show even with a 50 percent deposit. The only way to be sure is to get the whole amount and not give any refunds.*

However, Ruth Park is a regular customer. Every three months; just like a quarterly paycheck. Maybe I should bend the rules a bit for her. I'll talk to her tomorrow morning and see if we can work out a raincheck arrangement.

7

"Twenty!" Clayton said, dropping the whip and wiping his forehead with a piece of Raven's discarded clothing. Her ass was striped with red lines from the heavy whip and her breath was coming in gasps.

He ran his hand over her lower back and lightly touched the red marks. She gave a pleasured gasp and arched her back. She looked back at him and said, "Please?"

Clayton frowned. "You know I don't like to do that. It's too risky."

Raven smiled, turned and slid up onto the seat. She flinched slightly as her ass came in contact with the fabric but then smiled and slowly spread her legs showing him the glistening lips that were as flushed as her cheeks with the same excitement.

"Please, my Master, I need it. I need it bad," she pleaded. Then, she scrambled forward, picked up one of her discarded stockings and wrapped it tightly around her own neck. Holding both ends of the stocking in one hand, she ran her other hand over his chest and down, inside the sash, to stroke his cock.

"I'll do it myself, if you want," she said, pleading, the hand delicately cupping his balls.

"No," he responded, pushing her down on the chair again, "that's even riskier. I'll do it."

He shrugged his shoulders, allowing the robe to fall to the floor and stepped out of the boxer trunks. His excitement was such that his erection was looked as if it had been carved from adamantine minerals and a drop of pre-come glistened in the light of the single bulb.

A low moan escaped from her and her body quivered for a moment. Positioning himself behind her, he entered her with a smooth motion made easier because the passage was slick with her lubrication.

Raven made a scream of pleasure which was cut short as Clayton pulled the nylon tight around her throat. Softly, he whispered, "You fucking tease, one of these days you're going to go too far." Driving himself again and again against her, Clayton kept the nylon taut. He gasped, and sweat appeared on his forehead. She bucked and struggled. Again, she seemed the butterfly, but this time it was a butterfly throwing itself against the glass of the killing bottle in helpless despair. He

kept the nylon tight, but not so tight that she couldn't draw breath.

Finally, she bucked and released a scream so powerful that it was able to batter its way through her blocked windpipe. Clayton quickly released the nylon and unwrapped it from around her neck. Then, he went back to driving himself into her. Five, ten, fifteen strokes, and he gave a incoherent cry and fell against her.

The two of them lay for a few minutes, her body under him and his in her, and then, he got up and carried her seemingly boneless body to the bed where he tucked her in and climbed in the other side. With a mewing sound, she reached out her arms for him and drew him close.

"You always know what I want, darling," she said with a contented sigh and drifted off to sleep.

"And you get what you want," he said resignedly, "instead of what you need."

7

"Way cool," the young Indian man said softly to himself as he lay on his back on the floor of the darkened storage room, his ear pressed up against the air conditioning duct. The fly on his battered Levis as open and with one hand he manipulated a rock-solid erection while he strained to hear what has going on in the Parks' room. "God, would I love to have a hot-assed babe like that."

Suddenly, light flooded into the room as the door connecting it with kitchen opened. "Deer, Running Deer, are you in there?" a querulous voice called and the light was blocked by a bulky figure.

The young man stuffed his rapidly shrinking but unsatisfied erection back into his pants and called out as he stood up, "Call me Jimmy. I'm Jimmy Deerfield now."

48

"You are Running Deer, son of Raging Bear, just as I am Field of Flowers. What are you doing in a dark room?" the woman countered. Her hand sought and found a toggle switch on the wall, and the room was flooded with fluorescent light. She looked at the teenager with a jaundiced eye while waiting for an answer.

He looked left and right and then his gaze settled on the floor. "I was tired. I was just trying to get a little sleep before we had to make supper."

Field of Flowers, whose leathered face and black braids could have graced any of a thousand anthropological textbooks, looked suspiciously at the wall next to the young man's feet.

"You were listening to them again!" Reaching out, she grabbed him by the ear and gave it a yank. He accepted the punishment without protest. "You're a dirty, filthy boy with a dirty, filthy mind. These are evil people. They do bad things. It's bad enough we have to work for them. I think you want to be like them." Without releasing his ear, she pulled him out into the kitchen and picked up a heavy wooden spoon. Bending him over the chopping block, she hit the tight behind of his jeans three times. Each blow raised a tiny cloud of dust from dirt imbedded in the fabric. The boy took the punishment stoically.

When she released his ear, he shot upright and began to rub his ass while looking at her with a sullen resentment. Unaffected by his glare, she waved the spoon under his nose and said, "If I ever catch you listening at walls again, I will send you home and find a proper assistant, one who does not spy on dirty people and pretend that he is a *biligaana*, a white. Now, get back to work. The onions must be chopped... and chop them fine this time." Field of Flowers turned away and began to stir a pot of stock on the stove with the same spoon with which she had disciplined Deer. With each stroke of the spoon, she repeated in a low angry voice, "Evil people; evil people; evil people."

7

Tom had calmed considerably but his face was set with controlled rage. He sat so rigidly in his chair that an observer might be forgiven for guessing that it was painfully uncomfortable instead of the best Shaker workmanship. "Flame, this isn't some sort of personal vendetta. This Park woman abused Sue when she was helpless. She refused to honor a safeword and I think she was on some sort of drugs. I'm not trying to tell you your job, but I think you've got the potential for a lot of trouble here."

Flame looked at the tall man sitting across the desk from her and mentally agreed. Ruth Park's quarterly trips to Roissy helped pay the resort's enormous overhead, but abusing another person's submissive and ignoring a safeword meant that she was also dangerously unstable. It was a real case of damned if you do and damned if you don't. She leaned forward and said, "Let me talk to her. I'll read her the riot act and if anything... and I mean anything... happens again. I'll pitch her out on her ear." She could see that Tom didn't like that but he settled a bit on his chair.

"Your word. One more incident, however minor, and out she goes?"

Flame tried to put an engaging smile on her face. She wasn't sure that she had succeeded, but she said, "Well, I'm not going to kick her out for not kissing your ass, but if she goes off the rails again, she's gone."

Tom's face might have been a brick wall for all the emotion it displayed. His eyes flicked minutely as he studied Flame for a moment, and then he said, "That's acceptable," and stood up, extending his hand.

Flame got out of her chair, came around the desk and accepted the handshake. Then she reached out and pulled the tall man close for a hug. "Thanks for letting me handle it my way," she said quietly, giving him an extra squeeze.

50

When she released him, she noticed that Tom's face had softened a bit. He looked down at her, his lips hinting at the beginning of a hard smile. "This time," he said. "If there is a next time, I'm going to kill the bitch." Then, without another word, he turned and left the room. As soon as he was gone, the side door opened and Scum came in. The mask hid the expression on his face, but it came clearly through his voice. "That is one pissed dude. He was kidding about the kill part, wasn't he?"

Flame sank back into her desk chair. She picked up a letter opener and rotated it so the polished metal sent reflections dancing across the walls and ceiling. "I don't know. I really don't know. He's got a lot of guilt in there. He knows that he shouldn't have left Sue alone, but he can't let himself feel guilty so he gets mad. That's an unpredictable combination."

7

"... and so the bitch just kept hitting me until Tom came in and made her stop."

"Jesus, Mary and Joseph," Shawn said softly. "Now, you've learned what I did. She's a hellspawn." He looked at Kevin. "I hope you're thoroughly ashamed of polluting yourself with that bitch."

Kevin gave the lightly built man a hug and ran his fingers through the blond hair. "But I came back to you, darling."

Mollified, Shawn raised his face for a kiss.

Then, Kevin turned to Sue. "You're lucky Tom came around when he did. It sounds like she's capable of anything."

Sue's eyes went out of focus as she replayed the scene in the dungeon. "I'm not so sure. I think she may have been on something. She wasn't talking normally and she was slurring her words."

"That's no excuse," Kevin said. "She should know better than to mix play with drugs. At least, she wasn't using drugs

five years ago." He must have felt Shawn's sudden tension because he looked at the floor and said, "Besides, I can't stand the bitch."

Sue simply sat for a moment looking at both men, her eyes wide. Then she gave out the most incongruous giggle. She looked from one to the other. "Don't you see the joke? Miss High and Mighty comes here for a vacation and she finds not two people who hate her, but four. No wonder she was drinking or doing whatever she did."

Tom's face twisted in a wry grin. "Little Miss Sunshine seems to spread happiness wherever she goes. I was just talking to Flame. Raven's on probation. One more stunt..." He pulled Sue close to him. "... and she'll be history around here." He sat down in the armchair across a glass and steel coffee table from the couch where the two men were seated. Sue gracefully curled herself at his feet and rested her head on his thigh.

"Sue just pointed out that Raven seems to be cordially detested by everyone here," Kevin said. "You two were the only neutrals, and she'd done a pretty good job of alienating you."

"That she has," Shawn commented.

"I wouldn't say I detested her," Tom said slowly, "but after what happened..." He rubbed Sue's hair. "... I'd be a lot happier if I never saw Ruth Park again as long as I live."

Sue shifted so she could look at Tom. She grinned and there was a mischievous gleam in her eyes. "I was just saying I have an idea that might convince her to leave."

7

When Raven and Loki walked into the dining room a few minutes after seven o'clock, Flame and the six other guests were already seated at the long table which had replaced the separate tables used for the more informal meals. Before they could seat themselves, Sara Stewart stood and, turning to an obviously surprised Flame, said, "I think I'd rather eat in my

room, if you don't mind." As she walked to the door with George. Tom stood and added, "I agree." Kevin and Shawn simply rose without speaking and walked toward the door making a wide detour around the astonished couple. In a few seconds, the room was empty except for Raven, Loki and Flame.

Flame flushed under her dark skin, but said quickly, "I guess we will be having a much more intimate dinner than I had planned."

Loki flinched as Raven's fingers dug mercilessly into his arm for a moment and then she spoke, her voice with the undercurrent of an overstrained rope, "We'll eat in our rooms, too, please." She looked at Loki, suppressed fire in her eyes. "Come!"

Flame sat quietly for a moment and then said, quietly but with deep feeling, "Damn!"

7

Kevin stirred in his sleep. The warm fuzziness of sleep was disrupted by the increasing pressure in his bladder. He was conscious of the warmth of Shawn's body in the bed next to him and had a momentary stab of lust. Smiling wryly he thought, *First things first.*

The clock by the side of the bed read 12:14 in dim red letters as he padded across the room to the small but efficient bathroom attached to their room. Business completed, he became aware that he was slightly thirsty. In one end and out the other, he thought. He was about to draw a glass of water from the faucet when he remembered the small refrigerator in the common room down the hall and put the glass down.

The room was deserted when he reached it, but the refrigerator was well stocked with soda and juices. Selecting a glass bottle of apple juice, he was padding down the hall to his and Shawn's room when he heard a scuffing from the direction

53

of the dungeon. A young man, barefoot and wearing jeans and a T-shirt, appeared around the corner, stopped and looked wide-eyed at Kevin, then turned and went back the way he had come.

Back in the room, Kevin waited until his eyes again became adapted to the dim light and moved silently on the thick carpet until he was standing next to Shawn's side of the bed. Reaching down, he got a grip on Shawn's long blond hair, jerked his head back and said menacingly, "Slaves don't sleep. They are always ready to pleasure their master."

As always, Shawn struggled in confusion, still lost in sleep, but Kevin held him easily with one hand. With the other, he ripped away the covers, exposing Shawn to his lower thighs. Shawn's cock lay in its nest of pale hair, soft and vulnerable. Grasping the roll of circumcised flesh just behind the pale cock head, Kevin pinched hard.

"My *god*," Shawn arched, his eyes fully open now.

Bending close, Kevin said, "I said they are always ready to pleasure their master!" And he twisted Shawn's head so the blond man's mouth was against his erect cock. Willingly, Shawn opened his mouth and set to his task, all sleep forgotten. As he sucked, his own cock became erect and Kevin reached down and ran his fingernail along the growing tautness. Pulling back, he turned away from the bed, saying over his shoulder, "Head over the edge."

With a low moan, half anticipation and half fear, Shawn lay across the bed, his legs spread and his head hanging over the edge, throat extended and Adam's apple in sharp relief.

From the dresser drawer, Kevin extracted a multi-tailed cat with thin, knotted, cord-like tails. Standing over Shawn, he looked down at the pale, white body that seemed to glow in the semi-darkness. Casually, without force, he let the tails of the whip fall lightly on the other man's cock and balls, drawing it slowly back so that Shawn could fully appreciate the sensation of the hard knots.

"Please Master, I'm not warmed up yet," Shawn moaned.

"Yes?" Kevin replied his voice roughened by lust, "and your point?"

The first gentle stroke on the ghost-pale juncture drew a gasp, and Shawn's mouth fell open, drawn wider by his head-down position. Kevin crouched, and bracing himself with one hand against the bed, entered him. The next stroke was a bit heavier. Shawn's involuntary response was to open his throat, admitting the invading cock. Matching the whip strokes with this thrusts, Kevin drove deeper and deeper into his partner's body, pulling out only long enough for the other man to gasp.

Watching the cock carefully, Kevin distributed the whip strokes evenly over the juncture of the thighs until he noticed it begin to soften. Then putting aside the whip, he bent forward, taking the wilting organ in his own mouth and gently sucking it back to full erection. Slowing his inward thrusts, he increased the interval between them so that Shawn could gasp in lungfuls of air. Tickling the base of Shawn's balls, he felt them begin pre-orgasmic contractions. Shawn began to buck violently, arching off the bed. Reflexively, his hands clawed at Kevin's legs and ass.

Timing it to the second, Kevin pulled back just as Shawn's orgasm exploded. Balancing again on one hand, he brought the whip down for a last time, directly on the man's balls while pulling his cock cleanly out of his mouth.

"MUTTER, ME!" Shawn's exclamation was so loud that Kevin involuntarily looked toward the door.

"My turn," said Kevin gently and got on the bed. Slowly, still awkward from post-orgasm clumsiness, Shawn rolled over and began to gladly orally service his master.

56

MONDAY. Tom was in the middle of a pornographic and somewhat unlikely dream involving the Dallas Cowboy Cheerleaders and the current Miss Japan when he realized that he was not completely asleep. Opening his eyes and looking down the length of his body, he discovered the cast of characters had been somewhat reduced.

Sue looked up from between his legs where she had been industriously plying her tongue. "Awake already, darling? I hadn't really gotten started." Sue usually slept in the nude, but this morning she was wearing a pale blue silk nightdress.

Tom reached down and, grasping his wife by her ears, made her wiggle up his chest so he could give her a solid kiss on the lips.

"Didn't we agree that we were going to sleep late this morning?" he asked in a gravelly voice. "It was a late night and we usually don't do threesomes."

"Well," Sue answered, "it *is* late. I've been horny for almost two whole hours." She carefully slid off him and pulled him gently off the bed and led him to the upholstered armchair. When he started to protest, she simply put a fingertip to his lips. Pushing him back into the chair, she went over to the room's stereo console and turned it on.

Kneeling in front of him, she waited until the opening bars of Pachelbel's *Canon* filled the room, then, gracefully rising to her feet, she lifted her hands above her head and slowly turned so he could admire both the nightgown and the body within it. Putting her feet wide apart, she began to move in time to the music.

Lowering her hands to her shoulders, Sue let them slide forward and then down over her chest until each hand was cupping a breast. She held that pose for a moment, then, turned her back to him. Her gently swaying buttocks held his eyes entranced. When she turned back, her chest was naked. With a shrug of her shoulders, she let the upper part of the dress fall away from her back.

Slowly, she danced closer to him until he was close enough to see that her nipples were swollen and her eyes were glazing over with lust. Her hands played for a moment with the fastenings at her waist and the nightdress fell away. She turned and walked away from him, her hips rolling in a rhythm older than language. He hadn't noticed her high heels before, but now the magic they performed on her legs and buttocks were unmistakable. The limbs were thinned, and muscles cast in bold relief. The cheeks of her ass were tight and sculpted like those of a classical Greek statue.

Then, she turned back and flowed toward him, her hands gliding over her body. "Remain still, my darling," she said. "You have made me a very happy woman. This morning is my way of thanking you for that."

With lingering touches, she explored his body. Her lips followed her fingers as she stoked the fires within. For a moment, she paused and played with each foot, sucking on each toe in turn and licking his ankles. As she knelt before him, he admired the curve of her back as it tapered to her waist and then flared into the womanly ass.

Rising, she guided him to the bed and positioned him face up on the covers. The music had shifted to the theme from *Chariots of Fire* as she cupped his balls and poured massage oil

on the back of her hand. He gasped and arched as the warm oil seeped between her fingers and came in contact with his skin.

She gently kneaded the sack while studying his erection, the skin tight and the veins making a purplish tracery under the skin. With a tiny laugh, she ran her fingernail along the base of the organ almost to the tip and then fell forward on him for a passionate kiss.

He shifted and she enveloped him. Her body stiffened, and her eyes dilated with pleasure. However, she quickly recovered and, putting her hands on his shoulders, pushed herself into a sitting position. She picked up the plastic squeeze-bottle of massage oil from where it had fallen on the covers and put about a tablespoon of it on his chest. She slowly shifted her weight from side to side as she kept him trapped within her.

A sudden spasm made her stiffen, throw her head back and hiss between her teeth. Then she began to spread the oil across his chest, running her fingers through the hair to coat it and the skin below with the fragrant oil.

He watched her. His only movement was a widening of his eyes and a slight clenching of his fists as her fingers mapped new trails of pleasure across his skin.

Once his chest glistened in the candlelight, she pressed harder and leaned her weight against her arms. The movement brought simultaneous gasps of pleasure from both of them. Her fingers moved, pressing and kneading, as he rolled his head back and arched his back. A gasp escaped his lips.

Her hands were at his neck, warm and slippery. His hips began to move as his self-control slipped.

She ran her fingers, perfumed with the oil, over his cheeks and played with his ears. He responded by reaching up and roughly pulling her to him. His hips were driving into hers, and hers were responding with an abandon. He could feel her nipples sliding against each individual hair and sending tremors throughout his body.

He shifted, and they rolled over. Once on top, he re-doubled his thrusts. The world swam about them, and far

59

away he thought he could hear her "My darling, my darling" as he filled her to overflowing. Without his volition, his voice joined hers in a long scream that seemed to go on forever.

As her hands waved wildly, they struck the bedside table, knocking the package of tarot cards off. When it struck the floor, one card was ejected from the deck, the Devil.

Gasping and laughing, Tom and Sue clung to each other long after the tremors of the mutual orgasm had passed. Finally, Sue leaned back and grinned, "Wanna go to the dungeon and play, Daddy?"

Tom reached up and, grabbing a handful of her long hair, pulled her head down to the pillow. "Don't you ever get tired?" he said.

"Nope!" she replied cheerfully.

7

The doors to the dungeon unlocked. At this ungodly hour of the morning, Tom thought, most sensible people were sound asleep. However, he was surprised to find the red accent lights on and very surprised to see an unfamiliar figure lying on the rack. The light was too dim for him to tell immediately who it was, but the figure was undeniably female. *Who the fuck is in charge here, he thought. It isn't safe to leave someone in untended bondage. Didn't anyone learn anything from yesterday?*

His first thought was to slip out quietly and go to the dungeon on the other side of the building. This morning, he wasn't in the mood to have someone watch. Then, he thought that he had better check and see if she was all right.

She wasn't.

Tom turned and yelled to Sue, who had been standing quietly by the door, "Wake Flame. Raven is dead." Sue turned and vanished out the door.

Ruth's face was twisted and swollen above the knotted rope that cut deeply into her throat, but there was no mistak-

ing her identity. There was equally no doubt that she was dead. Her eyes were open and fixed on a point right where Tom found himself standing. When he touched her wrist to find a pulse the skin was cold and unresponsive. He jerked his hand away and, then stood frozen in indecision, speared in place by her staring accusatory eyes. He reached toward the knotted rope and then withdrew his hand. Slowly, as if backing away from an irate rattlesnake, he retreated to the door, but the image of the multicolored rope deep in her throat was sharp in his memory.

?

Flame was awakened by a pounding on the door to her room. She removed a police issue 9mm automatic from the nightstand and called loudly, "Who's dere?" Her tongue felt tired and clumsy from sleep.

The voice was muffled by the heavy door. "It's Sue. Come quick. There's been an accident in the dungeon. Raven is dead."

Flame felt oddly groggy and things seemed unreal, but she managed to get out of bed and put the pistol back into the drawer. She yanked a cotton bathrobe from the closet and wrapped it around her. Finally, she took a key from a hook on the wall and unlocked the large dog-transport cage where Scum was sleeping. "Put something on and follow me," she called to him as she headed for the door.

?

Tom was waiting outside the dungeon door when Sue and Flame came running down the hall. "Is she really dead?" Sue asked as Flame pushed past Tom into the dungeon.

"She's dead," Tom said, his voice shaky. "You know, I've never smoked in my life, but I'd kill for a cigarette right now." Then, realizing what he'd said, he looked away.

Sue reached out and hugged him. Then, she pushed him away. "If we can't do any good around here, we really should get dressed."

"I'll wait here in case Flame needs anything, but you get dressed and bring me a bathrobe."

Before Sue returned, Flame came out of the dungeon. Her face was hard and wrinkles furrowed her brow. "Did you touch anything?" she asked in a voice Tom had not heard before. It was tough and professional without a hint of sex in it – very different from the voice she used as Mistress Flame.

He shook his head and said, "I just looked – well, I did touch her wrist for a pulse."

"Damn," she said to no one in particular. "I thought Clayton was more careful than this. Maybe it was an accident and he panicked."

"How could that be an accident?" Tom asked.

Flame looked up sharply as if just remembering that he was here. "Raven had 'particular' tastes. It could have been an accident."

Tom's puzzled look was replaced by one that was equal parts horror and distaste. "She was into breath control?" he asked, obviously not needing an answer, but Flame nodded and said, "I've warned both of them not to do it in public. There isn't any way to do that safely and I didn't want any of the novices we occasionally get up here getting into bad habits." Then she shrugged, "But what they do in private is their own business."

An unfamiliar male figure, wearing a flannel shirt and jeans, appeared around the corner of the corridor. It took Tom a second to recognize Scum without his leather mask.

"Tom," Flame asked quietly, "please go back to your room and wait there with Sue. We have to figure this out."

62

She took a key off a hook on the wall and carefully locked the dungeon; then she dropped the key into the pocket of her robe. Turning to Scum, she said, "Come with me to the Parks' room. I want to have a witness."

As Tom and Sue went down the hall, he glanced back to check on Scum and Flame then whispered, "I think she was killed with my rope."

Sue looked at him in shock. "How?" she squeaked.

"I don't know." He shook his head. "I don't know."

7

Clayton was sound asleep amid the carnal disarray of the king-sized bed. Flame shook him lightly at first and then more vigorously until he opened a pair of groggy eyes and examined the room with the vague curiosity of a drunk in an art gallery.

"Clayton, wake up. Ruth is dead."

"Nonscense," he muttered. "Sh's rite here wish me." He patted the covers, first with a paternal confidence and then with an increasing desperation.

"Where's Ruth?" he demanded at last gaining control over his tongue and swinging into a sitting position on the edge of the bed.

Flame kneeled on the floor in front of him. "When was the last time you saw her, Clayton?"

He waved his hands in front of him. Flame leaned back a bit to allow him room to battle the demons that must have been tormenting him at that moment.

"Last night. We played in the room, and then I got tired and lay down. She was working at the computer. What happened? Where is she?"

Flame stood up and put her hands on his shoulders. "She's in the dungeon; she's been strangled."

He tried to rise but the awkwardness of his position on the bed and the fact that Flame was standing up and braced

allowed her to resist his attempt and then to push him flat against the mattress.

She put her face close to his. "There isn't a thing that you can do, and there's no way that I can let you into that room. You just wait here and I'll call Sheriff Clarke to straighten things out."

When she got up, he remained on the bed looking bemused and lost. Flame motioned for Scum to follow her out into the hall. When she closed the door behind them, she said, "Stay here and make sure that he stays in the room. I don't want him wandering around and I particularly don't want him trying to get into the dungeon."

7

When she had first met Sheriff John Clarke, Flame had thought he was a perfect Arizona lawman. This meant he was a bit more Texan than any Texan had the nerve to be. In casual conversation, he had admitted to her that from the time his father put a toy six-gun in the crib with him, he had wanted to be a sheriff, riding the range and putting the fear of god into the bad guys. She knew that in most cases like this, nature, the ultimate practical joker, surrounds such a noble soul with a body more suitable for an accountant than a cowboy. This time, however, nature got it right.

Six feet six and hefty – "My weight is a matter of discussion only between me and my scale," he had told her – Sheriff John Clarke could have stepped with his wide-brimmed hat and snakeskin boots into any of a thousand oat-burner Westerns. In the five years, she had lived in the country she had seen this facade fool some people into thinking he was dumb. Often, they weren't disabused of this misconception until they heard him reciting, slowly and carefully, "You have the right to remain silent. If you give up that right..."

That morning, he was sitting, feet propped up on his desk, watching dust motes drift in the draft from the air conditioner duct. *Quiet day,* he thought; of course, it must be 110 outside. *Raymond Chandler obviously never lived in the desert: At 90, little old ladies carve up their hubby for breathing wrong or looking a bit too hard at the bimbos in a Cosmo advertisement; at 100, they run their fingers over the edge of a carving knife and think about it, but at 110, even that is too much work. Tonight when it cools down, the deputies will be running a shuttle service from the bars to the hospital, but right now, it's quiet.*

The phone rang.

"Hello, Sheriff John Clarke speaking."

"Howdy, Eva. How are things at Roissy?" He pronounced it like two words, Row See.

As he listened to the next few words, the Sheriff didn't really move, but everything about him changed. The way a cat dozing in the sunshine goes on full alert at an unfamiliar sound without moving a muscle.

"What! I'll send someone immediately. No, wait, I'll come myself. Have you called Doc Barnes? Do that right away. I'll be up in half an hour."

7

It was actually closer to forty-five minutes when the Sheriff's black Ford Carryall pulled through the gate of Roissy. As he pulled into an open space, he noticed that there were four unfamiliar cars parked next to Eva's red Fiat and the resort's battered pickup truck. Two of them had rental tags, and the other two were from California.

As always, he hesitated, loath to leave the air-conditioned comfort of the truck for the hellfire of the desert. As the fine grit of his passage settled to the ground, he braced himself and opened the door. Simultaneously, a door in the building opened

and a familiar, shapely body emerged. Taking a deep breath, he opened the Carryall's door and stepped out.

"Eva," he said with a note of worry in his voice, "or should I call you Flame around here?"

"Better keep it Eva," she said. "This is your business, not mine." She turned and led him toward the building

"Not anymore, anyway," John said, following her.

7

Outside the dungeon door, John pulled on a pair of latex gloves from the small suitcase he had brought with him. "How many people have been in here?"

Eva paused then said, "She was found by Tom Burger and his wife, Sue. Tom said he just touched her wrist to make sure she was dead. I went into the room and looked but didn't touch anything. I think Sue just stayed by the door. After I looked, I locked the place and took the key. Here it is," she said handing him the key.

"One time I was up here, you told me that you had duplicate keys all over the place. Where are the others?"

"There's one hanging on the wall next to where the locks are. I took this one from this hook." She indicated a cup hook next to the door. "Another key is on my key ring in my office."

He unlocked the door and the two of them entered the room. "Is it the same as the last time you saw it?"

Eva looked around the room. "Nothing's changed."

John made a note of the position of each of the light switches then threw them to the "on" position, lighting all of the accent lights. "Is this all the light there is?"

She nodded and said, "When we are cleaning up, we bring in portable lights; would you like Scum to bring them in?"

"No, I've got photofloods with reflectors in the car. And by the way, what is Scum's name? I can't be using that in the report."

66

"You're going to have to ask him that yourself. He just showed up one day about two and a half months ago and talked himself into a job."

The sheriff looked at her and raised an eyebrow. "What about taxes and social security and all that sort of thing? Don't you have a social security number on him?"

Eve looked away and fiddled with the switches. "Well, since I don't pay him a salary and he isn't really an employee, that hasn't been a problem. He gets off being the house slave and I just feed his fantasies. He doesn't have any expenses, so you might say he is just living with me."

John shook his head and then carefully looked at each part of the room without moving. Getting down on the floor, he sighted along it, looking for anything he might inadvertently kick or step on when he went farther into the room. Then he walked over to the body. Bending close, he looked carefully at every visible part and, with a small piece of wood from his bag, poked at the rope that was sunken into her throat.

Eva remained by the door, watching every part of the examination. John took a camera out of the bag and took several rolls of pictures of the room and the body.

While he was involved with this, there was a knock on the outer door, and a muffled voice announced, "This is Doc Barnes; you in there, Sheriff?"

"One minute, Doc. I'm finishing up here." John put the camera away, and nodded to Eva who opened the door.

The first moment she had met him, Eva had thought that Doctor Mark Barnes was a perfect adaptation to the Arizona climate. Tall and rawboned, he never seemed to sweat, and unlike the sheriff, he liked the blazing desert heat. Some people wither like house plants in that climate; others become cactus. Doc was a cactus.

"All right for me to come into the room, John?" he said.

The sheriff nodded, and the doctor came over and examined the body. While the examination was underway, John took

67

out a sketch pad and a tape measure and started making careful drawings of the room.

"Want a time of death?" the doctor said.

"Of course."

"This one is fairly easy. The rigor, the body temperature and the postmortem lividity are consistent. This woman died between midnight and two a.m. this morning. The only thing that's inconsistent is the expression on the face. Usually, they relax after a while; I've never seen such an horrified expression on a corpus so long after death. Of course, I've never seen a strangulation where the ligature has been on this long. Most of the strangulations we get around here are with jealous husbands or boozed up bar flies.

"I should take this into town now?"

"Go ahead, and oh, do a full workup on this, including a rape kit." John pointed to one hand which was still in a leather cuff. "I think I see skin under the fingernails."

"DNA workup?"

"Right. Of course, by the time the state lab gets back to us, the perp may be on a second appeal," John said, half to himself.

"We may be in luck. The medical forensics program at State is getting into DNA matching in a big way. Asked me if I could send some business their way. If I phrase it right, we can have stuff back in a day or so."

"Can they certify the chain of evidence?" John asked. Courts have to be very fussy that the location of each piece of evidence must be known at all times from the time it is collected until it is presented in court. More than one solid case has been thrown out when, for example, bullets were mixed up in the ballistics laboratory.

"We can't use their findings right now; it's still experimental. Besides, the good news is they can do it in a day or two, but the bad news is that it just gives indications, not solid matches."

Seeing John's expression, he rushed on, "But we'll only use them for investigative data. I'll also send samples to the FBI lab in Quantico. They'll be a lot slower but we can use their report in court."

"OK, do it and since we can get some kind of result back this week, take skin scrapings from everyone here."

"Everyone?"

"Yup, everyone." John glanced at Eva. "Including the staff and the boss."

Eva's eyes widened but then she nodded. "Can't hurt, Doc. It wouldn't be good if a defense attorney claimed that the matching was half-assed. Let me know when you want to scrape my hide." Then she turned around and headed for her office.

7

"What's going on?" Kevin asked Scum as he came into the rec room with Clayton Park in tow. He had almost not recognized Scum without his mask and in jeans and a t-shirt. Both he and Shawn had been awakened by loud knocks on their door and a request to "Come to the rec room, right away!"

"There was an accident," Scum said. "Raven's dead."

"I don't think it was an accident," Sue said. "It didn't look like an accident." She turned and buried her face in Tom's chest.

Shawn's pale skin couldn't have gotten much whiter but his freckles seemed to stand out more distinctly. "You mean someone offed that Park bitch and you saw it? What hap..." he stopped in midsentence, and his eyes, along with everyone else's, was drawn to Clayton, who had been standing a bit apart from the group, eyes glassy and swaying a bit.

Clayton didn't move for a long moment and then, with a gasping sob, turned and stumbled toward the door. Shawn

looked at his friend and said, "Sometimes you can be such an asshole."

7

"I still can't believe it, Tom. She was dead." Sue tried to burrow deeper into her lover's chest while he stroked her hair. They had checked the toy bag as soon as they had gotten back to the room. One length of the red, black and white rope was missing.

Tom looked around the room with an air of someone for whom the world has shifted on its axis and who's still not sure why the sun is rising in the north. "We're suspects. The police are going to think I did it."

Sue pushed herself far enough away to look her lover in the face. "Don't be silly. We just found the body." Her eyes went wide. "We really did, didn't we? We found the body. Maybe if we had come in a few minutes earlier we might have caught the murderer."

"Or have gotten killed ourselves," Tom added dryly. "Besides, Raven was cold when I touched her. She had been dead a long time. We were probably sound asleep when it happened. But it was my rope that did it."

"You were here with me all night and we had that nice threesome until almost dawn."

"But after that, you were asleep; I could have slipped out." He sighed. "Besides, I think we are probably both suspects. Flame is sure to tell them what she did to you... and what I said."

Sue had clearly forgotten Tom's comments of the day before. Her eyes got wide and she put a clenched fist against her mouth. "My God," she said softly.

70

?

Eva was sitting at her desk when John came in and slumped into a chair. "How long have we known each other, Eva?" he asked.

She knew the question was rhetorical, but she chose to answer it seriously. "Just under three years. You came out to shut me down."

"That I did," he smiled wearily. I thought you were setting up an upscale whorehouse. I didn't have a clue." Then the smile disappeared. "It might still happen. This murder is going to attract a lot of attention. I'll try to keep a lid on it, but you know I can't guarantee anything."

"I'll never forget your face," Eva said, ignoring his last words, "when you ran my name through the LEAA computer. You came back in from the car with the cutest look of complete confoundment."

John laughed despite himself. "Well, what do you expect?. I figured I'd get a list of solicitation and prostitution busts and instead I find I've got a decorated New York cop. It didn't fit in my world."

"I thought I'd changed my world too. I wanted a place where the only murders I'd have to deal with were in paperbacks. Now I have a body in my dungeon."

As she said that, their eyes met and involuntarily both burst into laughter. When they got their breath back, John said, "Now, that does sound like a line from a paperback thriller: 'A body in your dungeon'." He reached out and touched her hand, giving it a squeeze. "Are you all right?"

"Yup," she nodded. "Still, I'm glad you are the one doing the investigation. Do you want to talk with the guests?"

Sue eyed the big man. Police uniforms were certainly different in the Southwest from what she was used to in New York. This guy looked like a cross between Matt Dillon and Crocodile Dundee, but he had an air of confidence and authority that was having a marked effect on her.

He had come in and introduced himself after they all had been hustled here from their rooms by Scum. *Now, Scum,* she thought, *there's a real change. It's as if he took off his servile manners along with the black mask.* She also noticed that he had also adopted more conventional clothing since the discovery of the body. Of course, she thought, none of us are dressing for the scene any more.

Even Flame, who was just entering the room, had donned a checked Western shirt, brown skirt and cowboy boots in place of her usual leather rig.

"Eva," John called out, "is this everyone?"

Eva? Sue looked around and realized the Sheriff was talking to Mistress Flame when she answered, "That's it, John. Field-of-Flowers had finished up the dinner by eight and was on her way well before midnight."

John swung a chair around and sat down, folding his arms over the back. He nodded at the group and said, "I'd like to thank everyone in advance for cooperating. As you probably already know, there has been a death here. It could have been an accident, but for now, we are treating it as a murder."

Sue didn't take her eyes off the sheriff, but she felt Tom giving her hand a squeeze and heard someone gasp.

"Now, I'd like you all to try to remember everything that happened in the last few days. Please, do it by yourself." He grinned. "I've found that when people try to remember together, they find themselves forgetting who remembered what."

"Your hostess, Eva – or, as you know her, Mistress Flame – is letting me use this dining room. I'm going to talk with you one at a time, but for right now, I'd like you to go to your rooms and wait there. Once I've talked with you, you can go

72

into the lounge or go back to your rooms. However, I would appreciate your not repeating what we talked about."

"Oh, yes, our local doctor will be along to each of your rooms. He has to take some skin scrapings from each of you as part of the investigation." John noticed a stiffening on the part of several of the guests. "I'm sorry, but we have to do this." He tried to look comforting, "Besides, it is completely painless." This seemed to relax them. In a way, he was disappointed. If the killer knew Park has scratched him or her, that person would be looking for excuses to refuse to give the sample, but everyone seemed to be acquiescing with only a bit of resistance.

"I guess I'll start with you," he said, pointing at Scum and walking out the door.

7

"You know, I can't get used to you without that damned mask," John said, studying the man across from him as if they had just met for the first time. From the sleek weight-lifter's body he had seen repeatedly, John had assumed that the servant was in his early twenties, but the man across from him looked to be well into his mid-thirties.

"You've been here for, what, two, three months? I've been up here five or six times in that time and you've always had the mask on."

"Gee, I didn't think it was, you know, appropriate. Like, well, after Raven getting offed like that."

He actually looks embarrassed, John thought.

"The mask kind of reminds me of, you know, my station."

"What exactly is 'your station'?"

"I'm the house slave."

"What exactly does that mean?"

"I clean, do odd jobs, take care of the guests, serve the food, do just about anything that needs doing."

"You mean you're some sort of a hired hand?"

"Well, you could think of it like that except I'm not hired. Mistress Flame doesn't pay me."

"That's what she told me." John cupped his chin. "You don't get any pay, boy?"

"No, sir," he looked down as he twisted his hands in his lap. "I don't expect you to understand it, but all my life I've had fantasies about serving a strong, beautiful woman. It broke up my marriage and made my life miserable. I couldn't be happier here. I'd like to spend my whole life as Mistress Flame's slave."

"You're right; I don't understand it, but I'll settle for you telling me what happened last night."

"There's like, not much to tell. I guess Mistress Flame had a busy day because about 11:30 she said she was sleepy, put me in my kennel and then went to sleep."

"Your kennel?"

Scum fiddled with his belt buckle. "Every night, she locks me into a dog cage in her room. I sleep there." He looked up, a plea for understanding in his eyes. "I like it; it makes me feel safe, like I'm wanted or something."

"So you were locked up all night?"

"Yes, she let me out when somebody banged on the door and said that Mrs. Park was dead."

"Are you a sound sleeper... damn, I can't keep calling you Scum now. What's your real name?"

"David Singletary."

"OK, David, are you a sound sleeper?"

"Well, no, sir. I sleep kinda light."

"Would you have noticed if Eva had gotten up during the night?"

"Oh, yes, sir. Every time she gets to go to the can, it wakes me up."

"Did she get up last night?"

"No, sir."

"Fine, David. Now, do you know anyone here who didn't like Mrs. Park?"

If he fiddles any more with that belt buckle his pants are going to fall off, John thought.

Singletary was silent for a long moment at then he took a deep breath. "Well, Mr. and Mrs. Stewart really hated her. It was, like, some sort of business deal. And she had some sort of argument with Tom and Sue Burger yesterday. That one was really nasty."

"What do you mean, nasty?"

"Park got Burger's old lady in dungeon B and started to beat on her. Burger came in and stopped it. I got the feeling that the old lady wasn't cool to the scene either and they both were ripping at Park."

"Anything come of it?"

"No, sir, Mistress Flame got it all chilled. She told Burger that she'd kick Park out if anything happened again. Burger was kinda hot. He said he'd kill Park in that case, but..."

"What?" John snapped. "Tom Burger threatened to kill Ruth Park?"

"Yes, sir, but he didn't mean it. He chilled but you could feel the bad vibes. Heck, man, last night was bad vibe central."

"Anything else?"

"Yes, sir, the queers had something against her too. They looked at her like she was day-old roadkill."

"Anything other than looks?" John asked

"No, sir, but all the guests walked out when she and that 'Loki' character came in to supper."

"All of them?"

"Yes, sir. They just all got up and walked as soon as she walked in. I had to bring them supper in their rooms, and that was a real pain in the ass."

"Were the Stewarts just going along?"

"Hell no, sir. They had been telling everyone that Ruth Park had cheated them out of millions of dollars. I didn't hear

75

much of it, but they were ripping about it, especially that little new bride."

Now, THIS is interesting, John thought. Murder usually had only a few sources, and the kind of anger that Burger had shown usually died pretty fast unless it was fueled by booze or another incident. Money, on the other hand, had a long and potent life span as a motive.

"What you're telling me is pretty much everyone here, except you and Eva, didn't like Park."

Scum flushed a bit. "Well, I don't think either of us liked her very much either..." Then, he backpedaled. "Of course, we wouldn't have killed her."

John nodded. "Why don't you go back to the common room and ask Mr. Stewart to come in. Oh, and I understand Eva asked you to keep an eye on Clayton Park. Please keep doing that."

7

Mr. Stewart was a very scared man. John thought that he had a very good reason to be. Right now, he was very close to the top of the sheriff's personal suspect list. Money was a potent motive. John decided to use the direct approach.

"Why did you hate Ruth Park?" he asked as soon as the man had sat down.

"I didn't..." Stewart trailed off. Then, he seemed to come to a decision. "Well, yes, I did hate her." This was delivered in a fairly flat tone but then it spiraled down into a plea. "But I didn't hate her enough to kill her."

"Somebody did," John said flatly with just a touch of menace.

Stewart looked up sharply. He seemed to forget his situation and snapped, "Lots of people would like to see her dead. She was a monster."

"What did she do to you?" John continued relentlessly.

Anger fought fear in Stewart's eyes. Anger won. "She stole my company. She just stole it."

"What do you mean?" John asked.

Stewart inhaled, let it out slowly, then began. "Do you know what The Millennium Bug is?"

"You mean the problems computers are going to have when the year 2000 arrives?" John asked.

"Exactly. My company Virtuality... well, really, I... came up with a new approach. Instead of fixing each program individually, I wrote a virus that would do it automatically, on any computer, anywhere."

John's battles with the computer age were limited to typing out reports on a word processor. Anything more complex he left to some of the younger guys in the sheriff's office who actually seemed to like the damn things, but he wrote down what Stewart had written and nodded.

"It was going to be worth millions... hell, billions, but I had a lot of start-up costs. It isn't easy getting a company started, particularly when that company is built around one product that isn't completely ready." Stewart's look changed again; now he looked like a particularly battered beagle. "I had to borrow a lot of money. Then I took the company public." Seeing the sheriff's puzzled look, he backtracked. "I sold stock. It was the only way to get the operating capital I needed."

His lips curled in a snarl but the beagle remained in his eyes. "That was when She came along. I thought I had kept enough stock for myself so I could keep control of the company, but she bought up both a lot of the stock and the outstanding debt. It must have cost her millions. I didn't even see it coming. Then, the next thing I know is the company is firing me... me, the man who created it."

John felt a bit of sympathy for the man, but at the same time, realized he was hearing a pretty strong motive for murder. He asked, "But you still have stock; when your program goes on the market won't that make you rich?"

The beagle vanished, incinerated in the flames that flashed from Stewart's eyes. "That's the worst. When she had control of the company, she *sold* my program to one of her other companies. She gutted it. The bitch raped it! She made sure I wouldn't get a cent!" Stewart's hands rose in a clenching movement and it would have taken a truly impoverished imagination not to see Park's throat between them.

John had perhaps a hundred pounds and almost a foot on Stewart. He was armed and had Eva's substantial desk between them. Still, for a moment, he was afraid of Stewart, such was the man's fury.

A fury that waned as fast as it had waxed. Stewart lowered his hands and looked sheepishly at the sheriff. "I guess that doesn't exactly clear me, does it?" he said.

Despite himself, John had to smile. "No, I'd say you had a pretty good motive, but I'm trying to keep an open mind now. Where were you last night?"

"Sara and I had supper in our rooms. I think you can get Scum to confirm that. He brought the food to us. After that, we played a bit, watched television and went to bed."

"When did you go to bed?"

Stewart thought for a bit. "I'd say we were asleep by 10:30. The next thing I knew was when I heard the noise in the hall this morning."

John looked at him carefully. "Have you ever been in the dungeon where Park was found?"

Stewart hesitated, turning his head as if he were trying to get his bearings. "No, when we arrived Flame showed us one of the dungeons but I'm pretty sure it was over there." He pointed toward the left side of the house. "She told us about the other dungeon, but we didn't go in."

John wrote it carefully on his pad and then said, "That's all for now. Would you ask your wife to come in?"

7

The moment Tom Burger walked in, John knew something was up. There was an indefinable something, so instead of asking questions, he waited.

Burger seemed to be engaged in an internal struggle, then he said, "Have you identified the rope yet?"

This caught John off guard. For a moment, he couldn't even figure out what Burger was talking about. Then he caught on. "You mean the rope that Park was killed with?"

Burger nodded.

John mentally held his cards close to his chest. He had noticed the unusual weave of the rope but there hadn't been time for any forensics yet. "We know a bit; why don't you tell me what you know about it?"

"It's mine," Burger said flatly.

John forced himself to nod as if this was just confirming something he already knew. "You got any idea of how it got around her neck?"

Burger shook his head. "None, but we don't keep close track of our play bag. The people we know in the scene don't steal so ..."

"Seems some of them kill people," John said

This seemed to hit Burger hard. He swallowed and continued. "Really, we rarely lose any toys. People just leave other folk's gear alone." Then he paused, "Park went through my bag yesterday when she was with Sue."

"Yes, I wanted to hear about that. I've heard the story, but I want to hear your part."

Burger's jaw tightened but his voice didn't change. "Sue and I were playing. I left her alone in the dungeon for a few minutes, it's part of a kind of sensory deprivation scene, makes everything more intense. I figured she'd be all right and could call out if there was a problem. I just didn't realize how good the soundproofing was. Park found her that way."

79

John could see the iron effort Burger was putting into keeping his voice level. "She beat Sue. She beat her without permission and even after Sue had safeworded. If I hadn't come in to stop it..." He stopped and looked at John. His voice relaxed a bit. "Did you know she was on angel dust?"

Something in John's face must have told him that this was new information. "She was acting weird and then she dropped a packet. I've lived in New York too long not to have a nodding acquaintance with that kind of shit."

John noted the information on the pad and said, "Do you remember what you told Eva you'd do if Park acted up again?" He could see that Burger recalled his words quite well, but the man remained silent. John consulted his notebook. "I think the exact words were supposed have been, 'I'll kill the bitch.' Can you confirm that you said that?

Burger gripped the arms of his chair. "I was upset. I didn't mean it."

John was patient. "Did you say it?"

Burger crumpled a bit. "Yes."

John steepled his fingers. "Only one day and you'd already gotten to the point of making death threats?"

He could see that Burger was ready for the question. The man hardly flinched. "If you know about my comment, then you know about the circumstances around it. I was overwrought."

"Yes," John responded. "However, it was a pretty serious threat and given the circumstances..."

Burger flushed. "I know. It was a pretty stupid thing to say in any case, but I didn't have anything to do with the murder."

"Well, where were you and your wife last night?"

"We spent the entire night in our room. We were up quite late playing and didn't get to sleep until late." Burger looked up almost defiantly. "We were playing..."

At that point, there was a knock on the door that led out to the courtyard.

"John," Eva yelled through the door, "could you give us a hand?"

"Go back to the common room, Mr. Burger; I'll talk to you later," John said, swinging himself to his feet.

Out in the courtyard, Scum was struggling with Clayton Park, while Doc Barnes and an attendant looked on. The rubberized bag containing Ruth Park had just been loaded onto the coroner's van and Clayton was trying to push past Scum to get to it. When he saw John approaching he turned and appealed.

"Sheriff, I just want to ride in with my wife," he said, holding his hands out.

John positioned himself between the man and the waiting van and signaled the attendant to get on with it.

"I'm sorry, Mr. Park," he said. "Even under normal circumstances you couldn't ride along." Then he made a gesture similar to Park's. "I'm sure you understand. We just couldn't allow it."

Park's shoulders fell and he turned back to the main building, shaking off Scum's well-intentioned helping hand.

John thought about directing Park into the office for an interview, but the man seemed to be deeply shaken so he said, "Scum, why don't you take Mr. Park back to the common room and ask Mr. Black to come to the office."

7

Eva was sitting, elbows on her personal living-room desk, fingers pressing into her temples, when John knocked and then entered the room accompanied by Kevin. "I think we may have something," he said without preamble. "Kevin Black said he saw someone in the building last night... someone who wasn't a guest."

Eva looked up, sharply. "Did he give you a description?"

"Yah, a guy, about twenty, jeans and T-shirt. And he said the guy was barefoot."

"Come with me," she said, and led him back into the Roissy office. She opened the drawer of a filing cabinet against the wall and took out a file folder with "Contracts and Staff" on it. Opening it, she extracted a photocopy of an Arizona driver's license in the name Jimmy Deerfield.

"That's him! That's the guy I saw in the hallway," Kevin exclaimed excitedly. "You mean I might have been face to face with whoever killed Park?"

John's face was professionally blank. "Well, Mr. Black, we can't say that precisely, but," he glanced at Eva, "I'm certainly going to have a chat with Mr. Deerfield."

7

Outside the room, he turned to Eva and said, "I'll finish up the interviews. Do you know where Jimmy is living now? I haven't seen him for a couple of years since we had that little problem with him at the package store in town."

"I think he's still living with Field of Flowers, but if you want to get your hands on him," Eva grinned, "I'll bet he's about 100 feet from here in the cook shack."

John swiveled his head with such speed that Eva thought she could hear the vertebrae crack. "Damn it, woman," his voice low with controlled frustration, "why didn't you tell me this before?"

Eva didn't wilt, but matched his stare, even though it meant looking up at almost a forty-five-degree angle. "He isn't going anywhere, and in any case, you'd want to get a confirmation from Kevin before going out half cocked."

John downgraded his glare a couple of points and gave a grudging nod.

They walked out of her office and were walking down the corridor toward the back of the kitchen when they heard a snoring sound. Eva and John looked at each other, then ap-

82

proached an open door. Looking in they say Clayton Park, sprawled out across a bed, sound sleep.

John raised his eyebrows. "That's either one cool character or something is fishy here."

Eva nodded. "You know, I noticed he seemed a little glassy-eyed. I had put it down to shock." She paused. "But now, I wonder."

John returned the nod. Leaving Park undisturbed, he went down to the rec room where Doc Barnes was talking with Sue Burger. John motioned the older man over to the door.

When he arrived, John told him, "I've got a funny feeling about Clayton Park. Have you done the skin scraping yet?" When Doc nodded, he went on. Park is down the hall in one of the vacant rooms snoring his head off. He nodded in response to Doc's surprised look. "Yup, sound asleep... like a baby. Can you get a blood sample too? I'd like a full toxicology workup. I'm wondering if our boy may have been taking something."

Doc just nodded and went back into the rec room to get his bag while Eva and John continued out the back door. Both flinched at the blast of hot air when John opened the door.

The cook shack was detached from the main building, a throwback to the time when a lack of water usually meant any fire destroyed the building... and any building attached to it. White smoke came from the chimney and as they approached the building there was a clank of metal on metal.

Field of Flowers was standing over a large cauldron stirring with energy that would have been remarkable in normal temperatures, much less the oven-like conditions that existed in the adobe building.

When she sensed or heard their approach, she looked up with a glare, which intensified when she saw two silhouettes in the doorway. "What is it?" she snapped.

John stopped in the doorway and said, *"Yaa' en t'teeh."*

Field of Flowers leaned forward and stared. "Is that you, Sheriff?"

Without waiting for an answer, she wiped her hands on her apron. "I'm sorry I was rude. Running Deer, the lazy boy, was nowhere to be found this morning. He isn't much help, but..." She paused, watching the two exchange glances.

Before she went on, John asked quietly, "When was the last time you saw Jimmy... er, Running Deer?"

"He didn't come home last night, the evil boy." Then, she turned her full gaze on Eva. "It is your fault and the fault of those you bring here." Then, she looked away and continued, her tone taking on a tired note, "And mine, for bringing him here."

Eva flushed but kept her own counsel.

"Do you have any idea of where he could be?" John continued.

Field of Flowers turned back to her cooking, stirring the pot with renewed violence. "No. Sometimes he goes to the lake." Then, she stiffened and her voice became sharper. "We were a happy family until this evil came here. I should have heeded the padre and not come near this place."

John wasn't finished. "Do you know anything about a killing here last night?"

There was a muffled splash as the stirring spoon slipped out of Field of Flowers' hands. "There was a killing?" she asked in a voice suddenly numb. Then, then she whirled. "Was Running Deer involved?" she asked, eyes pleading.

John held out one ham-like hand. "Someone saw him in the building last night." He paused and continued tactfully, "We just want to see if he's seen anyone."

"Running Deer was there at..." Field of Flowers staggered to a chair. "...night?" She looked from John to Eva and back again. "What was he doing?"

"That's one of the things we want to ask him," John said.

Field of Flowers' lined face might have been cut from stone but a lively agony looked out from her eyes. She lowered her eyes, paused for an uncomfortable moment and then said softly. "He uses his uncle's trailer on the north end of the lake.

He goes there a lot... too much." Then, she lowered her head into her hands.

The two looked at each other again, and quietly withdrew.

Outside, Eva turned to John, but before she could say anything, he put his finger to his lips and pointed toward the main house.

When the door closed behind them, bringing a merciful relief from the heat, Eva said, "I have trouble believing that Jimmy could have done this. He's always been a bit spooky and shy, but relatively harmless."

John shook his head. "I'd have gone along with that before. He's had a few run-ins with my office, but they've been shoplifting and other kid's stuff. Nothing violent and certainly nothing that'd point to something like this."

John looked at his watch. "Can you tell the rest of your guests that I'll be back to talk with them? I've gotta take a drive. Tell 'em nobody leaves; nobody even goes out the gate."

Eva nodded.

John walked down the hall while Eva turned into the common room.

A satellite feed of CNN showed on the television and the eight people were lounging around showing various degrees of interest or boredom, except for Clayton Park, who was sitting in a corner staring at the floor and some vision of a personal hell. When Eva appeared, everyone except Clayton jumped up and converged on her. The babble of questions was so intense and incoherent that Eva was pressed back against the closed door.

She held up her hand for silence, and when the noise level moderated, she lowered it and said, "The Sheriff has gone out to check some information; he'll be back soon. Until then, he's ask that everyone stay in the compound." She tried for a bright and cheerful tone and managed it... almost. "Hey, guys, you came up here to have a vacation. Nothing's preventing you from enjoying it."

"Yeah," Tom retorted, "nothing but a dead body in the dungeon."

Sue looked at Eva with understanding and poked Tom hard in the ribs.

Eva's bid didn't convert them into a bunch of happy vacationers, but there was a certain momentary relaxation of the group's bowstring tension. Then one by one they glanced at Clayton and the emotional shroud descended.

Sue took Tom's hand. "Let's go back to the room, Darling," she said with a forced smile. Tom glanced at Eva and got a quick nod.

"He just said nobody should leave the compound," Eva said quietly.

Sue, Tom in tow, walked to the door, paused, looked back and waved to the others.

Once outside, he said, "You don't really want to play?"

She gave him a quick smile and turned on her "little girl" voice. "But I'm your horny wench. I'm *always* ready to play." Then, more seriously, she added. "This has me freaked out; a little cuddling would be a great idea."

Tom smiled and held her close in the hallway outside their room. Then, he stiffened.

"What's wrong?" Sue said, sensing his sudden tension.

When he didn't reply she looked up and followed his gaze to the yellow "Police Line - Do Not Cross" tape across the dungeon doorway down the hall.

Suddenly assertive, she tugged loose, took his hand and led him into their room, closing the door behind her.

Back in the common room, Eva sat down next to Clayton. "Sheriff John thinks he may have a witness or even a suspect in..." She paused. "...what happened last night."

For the first time since Eva had entered the room, Clayton looked up. "You mean he's really investigating?"

"Just what do you mean by that?" Eva snapped, surprised and defensive for her friend. Then, as she spoke, she realized his meaning.

86

"I just thought that everyone assumed that I did it," he said softly, his eyes dropping again to the floor.

Eva bit her tongue as the thought, *Well, kiddo, you ARE first in line,* leaped to mind. Instead, she forced a smile. "I've known Sheriff John for a long time. He's a fair-minded man and he doesn't jump to conclusions. He's checking out a lead right now."

7

Dry Lake wasn't. At one time, a state hydrologist had explained to him that the lake was a surfaced aquifer. Water flowed underground through beds of buried sand and rock from the distant mountains until it surfaced in this shallow depression where the fierce sun steamed it off into the parched air. It was shallow, muddy and surrounded by scrub bushes and low trees. If it had been nearer civilization or on privately owned land, it would probably would have been a locus of a small town. Out here, deep in Federal property, it was primarily a resource for local cattlemen. Several rental plots pivoted outward, with the lake as a common meeting point.

John had been aware that some of the locals had erected small fishing and hunting camps on the border of the lake, just far enough past the scrub line so as not to catch the eye of any federal types who might demand that they tear them down or move them. Frankly, he didn't give a damn. A favored structure for this was an old trailer or camper, pulled off the pickup and supported by a few cinder blocks.

He parked his car at the closest approach to the lake's northern end. For a moment, he considered taking the pump shotgun from its quick release mount just behind his seat, but instead just patted the .45 caliber revolver in its holster on his belt and set off through the scrub.

Going was fairly easy, with the larger trees well separated and the low scrub hardly reached to his knees. When he finally

broke out on to the margin of the lake, he saw a long low mudflat stretching about a hundred feet to the water's edge. *Shit, he thought, this whole state is one big sandpile and I get to wade through mud.* However, the sunbaked layer resisted his first tentative footstep and then a few more energetic kicks.

Turning left, he walked along the margin of the lake looking carefully at the mass of bushes and trees. John had expected to find a couple of covert structures set up by locals to facilitate their hunting and fishing expeditions. However, the first hundred yards yielded two shacks and a dilapidated construction trailer. By the time, he had covered a third of the lake's northern edge, he had located twenty structures of various types, including two expensive-looking travel trailers. No one had been home in any of them, and aside from some decrepit fishing gear and unimaginative porn he hadn't found anything inside.

Damn, there's a fucking city up here. He considered informing the Interior Department representative about the squatters then shook his head. *Fucking feather merchants can take care of themselves. FUCK!* His left foot had hit a place where the baked surface was a bit thin. His shoe, sock, and about three inches of his pants had dropped into the underlying mud. He gave the leg a shake, but the mud clung and he could feel the water soaking through. He gave a quick glance at the nearby edge of the shrunken lake, but realized that long before he could get close enough to the water to rinse the mud off, he'd be wading through the sticky stuff.

Stifling a curse, he continued along the shoreline, paying a bit more attention to the surface as he continued to scan the brush. *How in the fuck am I going to even know if I've found Jimmy's place?*

A muffled scream came from just ahead and he froze for a moment before moving sideways into the cover of the shoreline brush. The scream was repeated and lasted long enough for John to make out the shape of an old Airstream trailer through the bushes. Drawing his gun, he moved closer. Now, he could

88

hear a woman's voice rising and falling through the aluminum walls.

As quietly as he could, John drew his pistol and cocked it. Putting his finger across the trigger guard, he flattened himself against the metal wall and reached up for the door latch. The conversation within was still muffled but he thought he could hear the words "thank you" over and over again in a feminine voice.

Jerking the door wide he flung himself into the trailer swinging his body from side to side so he could size up the interior.

As he had expected, Jimmy Deerfield was there, standing next to a young woman bound in a wooden framework that held her almost parallel to the floor with her legs spread. As far as he could see in the dim light, she was naked. Jimmy was too, his erection visibly waning but glistening wetly in the light from the door and the single window.

Both occupants turned wide eyed, disbelieving looks at the armed lawman.

Jimmy spoke first, sort of an incoherent, questioning "Wahhh?"

John silenced him with an abrupt gesture of the gun. "You are under arrest," he said with practiced ease. "You have the right to remain silent..."

Throughout the recitation, both maintained their almost bovine stare, but when John finished with "Do you understand these rights?" the woman let out a despairing scream of "Daddy will kill me."

This was not the reception John had expected when he first saw the tableau. Instead of incoherent happiness at being rescued, he was reading the kind of despair he encountered when he had to occasionally break up teenage drinking parties. His gun and his jaw started to droop. Catching himself, he returned both to firmer positions and said, "What in the hell is going on here?"

89

John wasn't the only one getting a grip on the situation. The young woman snapped, "Jimmy, get me out of this thing," in a tone of voice that seemed more "tie-er" than "tied."

John backed up to a straight-backed chair a safe distance from both of them and sat down, de-cocking the pistol and resting it in his lap.

Understandably in the circumstances, Jimmy's fingers were making hard work of the numerous buckles and straps. Under other circumstances it might have been amusing, but now, John was thankful of the distraction which permitted him to evaluate what he had walked in on.

Free, the woman pushed Jimmy to one side and gathered up a pair of black jeans and a t-shirt. Ignoring a pair of white panties and a bra, she put the things on and gave John an appraising look.

With an ingratiating expression that was a bit too calculated to be completely convincing, she said, "Do we have to tell daddy about this, Sheriff?"

Silently thanking the fates that he had had a moment to think, John ignored her and said to seemingly shell-shocked Jimmy, "Turn around, put your hands behind you and walk backwards toward me."

As Jimmy complied, John stood, holstered his gun and took out his cuffs. Snapping the cuffs on and double locking them was the work of a moment.

"Go over to that couch and sit down," John directed, aware that the combination of the soft couch and the hand-cuffed hands would put Jimmy out of action as effectively as several yards of chain... or, he thought, that contraption she was all tied up in.

Once Jimmy was seated, John sat down again and turned his attention to the girl.

"Who are you?"

He was surprised to see her startle at what he would have expected to be a seemingly obvious question.

"You mean daddy didn't send you after me?" she asked.

90

"I didn't have any idea you were out here," he replied honestly. "I came out to talk to Jimmy about an ongoing investigation." John didn't add, "in which he is a prime suspect."

For the first time, Jimmy formed coherent words, "What investigation?"

John had the feeling that, beneath the underlying nervous anyone would have felt in a similar situation, there was just honest curiosity. Hiding his reaction, he responded, "About what happened at Roissy last night."

Now the puzzlement was obvious on Jimmy's face. "What happened? I didn't see anything odd."

Keeping a level tone, John asked casually, "So you were there after your shift?"

Fuck, it's a blush, an honest-to-goodness blush, he thought watching the young man's face.

Jimmy looked down. The "Yes" was barely audible.

John wanted to find out more about the young woman but he knew he was on a roll with Jimmy and had to press harder before the young man could get his balance. "What were you doing there?"

The blush deepened. Jimmy gave the woman a quick glance and then looked down again. "I wanted to listen."

"Listen?" Of all the possible motives for an evening visit to Roissy, this was one that John hadn't expected.

Jimmy gave a slight shudder, as if something inside had burst and the words tumbled out so rapidly that John had to lean forward to catch them.

"There's an airshaft, you know, one of those air conditioning things. It lets out in the storage room next to the dining room. If you, I mean if I, put my head real close to it I can hear what's going on in the other rooms. I mean, these people really do it. It isn't like those dumb posed pictures in the magazines; they really do it, and I can hear them. I mean really hear them, the whips and the stuff, and they talk about it too, and I can listen."

91

With a look of horrified anticipation, he turned to the woman, but she surprised both him and John by cooing in a fascinated tone, "Cool, you mean you get to really hear them?"

With a touch of stupefaction, Jimmy looked at her and said, "Yah, it ain't loud but you can hear everything."

Her eyes glittering, she said, "You think you could..." Then the couple remembered where they were and who was watching them with a loaded gun in his hand. The woman began a fascinated examination of the rings on her right hand while Jimmy looked back at John, gulped, and said, "Ain't nuthin' wrong with just listening, is there?"

John thought for a moment and said, "I think Flame may have something to say to you about your habits, but that isn't important now. Did you see or hear anything unusual last night while you were in the storage room?"

John hadn't thought it was possible but Jimmy managed to look even more embarrassed. "I sorta didn't get to the storage room. I mean I didn't get that far. I was in the hallway when the Chinese woman caught me. I mean, I usually avoid the guests. Miss Hernandez doesn't like me talking with them and Field of Flowers.. well, she thinks they are all really bad people."

Again, Jimmy looked at John, pleadingly. "They aren't. I've met some of them and they're real nice. They just like... different things."

Then he looked at the young woman pleadingly, "You'd like them. After all, they told me to tell you what I wanted to do."

Abruptly, the rings lost their fascination. Looking up, she said in a sharp, brittle voice, "You told them about *me*!"

Jimmy shrugged helplessly. "I didn't say who you were. I just told them that I had always wanted to do this to my girlfriend and they convinced me that I should ask you. That's why I came over this morning..."

John cut him off, earning a glare from the woman, "What in the hell happened at Roissy last night? You were going to go

to the stock room and do your little peeping tom number."

"I didn't peep," Jimmy said defensively, but John cut him off again testily. "I don't care if you were going to take pictures and have them autographed. What happened?"

Jimmy settled down again, "Like I said, the Chinese woman saw me, and anyway, I was too far from anything I could duck into and she smiled at me. She was so nice. I told her I worked there and she asked me if I was 'in the scene.' I knew what she meant because I had been listening for a long time. Well, I said I wasn't but I was real interested in it."

Jimmy fidgeted. "You gotta understand she was real nice and seemed interested in me. She asked me a lot of questions. None of the other guests had really ever talked to me. I even told her what I'd been doing and she said that watching was better than listening.

"Well, she took me back to her room.. her husband was there and..." Jimmy looked up with something like defiance in his eyes. "...and they let me watch. Tied her to the bed and spanked her; then he ran a little spiked wheel all over her body. He did all sorts of things to her." Jimmy's voice was rising again. "And she loved it. I could see she loved it. Then she asked if I'd..."

John raised his hand. There were things he didn't need to know. Hell, he thought, there are things I don't *want* to know. Anyway, the young woman looked as if she were going to charge in, and from the daggers she was looking at Jimmy, he figured that the interruption might throw the whole thing off course. "When did you leave?" he said, a bit more sharply than he had expected.

Jimmy thought. "Late, real late. I went to the coffee shop near Mary's..." John mentally tagged the young woman as "Mary." If she wasn't, he didn't want to be in Jimmy's shoes. "... then when I figured she was awake I called her. We sort of got together and I told her... I asked her." Jimmy's voice faded off. But what he had both asked and told was abundantly clear.

"Listen carefully, Jimmy, at anytime while you were at Roissy last night did you see or hear anything out of the ordinary?"

John gave the boy credit for obviously thinking over the question and seeming to review his memories before answering, but a "no" is still a "no."

"Nothing?" he prompted.

"I didn't see anyone other than Sue and Tom and I can't recall hearing anything odd," Jimmy responded shaking his head.

John turned to the young woman. "And who are you?"

She was glaring so intently at Jimmy that she didn't respond until he had repeated the questions. She jumped a bit and her face faltered through a series of expressions until she settled on what John thought could best be described as "teenage antagonism."

"I'm Mary Rosario," she said haughtily. Then, the facade crumpled and she importuned, "You don't really have to tell my daddy any of this, do you?"

"And your father is?" John started to say; then he realized why the name seemed familiar.

"You're Councilman Rosario's daughter, aren't you?"

Fighting to keep his face unreadable, John could think of only one word: *shit!*

Praying silently, he asked, "How old are you, Mary?"

"I'm 18."

John's only external reaction was to slowly let out the breath he had been holding, but inside, he mentally kissed the girl on the lips and danced around the room waving his hat.

"Well, Mary, you're an adult, and whatever goes on between you and someone else is your business. However, this is part of a murder investigation, and I'll have to file..."

"*Murder!*" Both young people leaped to their feet staring at John.

He motioned them both to sit down.

94

Unemotionally he said, "Sometime during last night, Ruth Park, a guest at Roissy, was killed by person or persons unknown." Then, moderating his tone a bit, he looked right at Jimmy and said, "That's why it is so important you tell me anything you saw or heard while you were there."

Jimmy flushed, but whether it was with guilt or embarrassment, John couldn't be sure.

"Honest, Sheriff, I didn't see anything. That nice lady Sue and her husband was the only people I saw."

This reminded Mary, who had evidently been thinking about the murder, about other things that had happened last night, and she glowered at Jimmy, muttering, "Sue."

Figuring that Jimmy was in deep enough trouble right here, John said, "I'll have to talk with the Burgers, and what was the name of the coffee shop where you went after you left Roissy?"

After Jimmy told him, Mary reiterated her question.

John replied, "I'll have to put this in a report, but it is an internal document. As long as Jimmy is telling the truth and his story checks out, I don't see any reason that anyone would show it to the councilman."

John uncuffed Jimmy and prepared to leave the couple to their discussion. On the way out, he remembered something and turned back to say, "Jimmy, go by Doc Barnes' place. We're taking skin samples from everyone who was at Roissy last night."

Jimmy looked at him in surprise. "You mean like O.J. Simpson?"

John snorted, "No, this one we are going to do right."

7

John was heading back to town and the small mountain of paperwork on his desk. Gloomily, he considered that it had probably grown a foothill in the time he'd been at Roissy. I'll

95

run through a few things, turn some of the stuff over to the deputies and then head back to Roissy. Still have to talk to the Burgers. He made a face. I'll have to check out Jimmy's alibi too. Still, I'll be happy if the kid didn't have anything to do with it. Unwillingly, his mind wandered back to the image of Mary Rosario, and he felt his cock tighten.

Unprofessional, he thought, and then smiled, she did have the cutest...

The thought was cut short as a white Mustang convertible shot by going the other way, its pressure wave rocking the Carryall. Putting aside the erotic for the prosaic, John switched on the lights and siren, pulled the heavy car into a wide turn and picked up the mike.

"Lois, this is John; we got anyone out on 89¿"

There was a pause and the dispatcher's voice came on, "Little John just finished up checking on a car break-in on the scenic overlook. He's heading into town now."

John thought fast. "Lois, tell him I got a speeder in a white Mustang convertible heading toward him and ask him to meet me on the tac frequency."

Even with the accelerator to the floorboards and the heavy overpowered V8 under the Carryall's room doing its best, John was having a hard time keeping the Mustang in sight.

"I'm here. Whatcha want me to do, Sheriff¿" The voice that came out of the radio had the eagerness of a kitten seeing a dangling shoelace.

"Where are you, John¿"

"About a mile east of the overlook."

John did a quick mileage calculation. "Turn around and go back to that straight stretch near the overlook. Park across the road about two thirds of the way west. Turn on your lights.

"But, Sheriff, they'll see me a mile off."

John took a minimal risk by taking his eyes off the rapidly moving road and looking heavenward for relief. As always, it didn't come.

96

"That's the idea," he said slowly and carefully, hoping that "Little" John would pick up a bit of the sarcasm in his voice. "This dude is moving like a rocket. I want him to have all the time in the world to realize you're in front of him and I'm behind him and he ain't going anywhere. We rush him and he may make a mistake and bend up that nice car of his."

"OK, Sheriff, I see. I'm almost in position."

A nice kid, John thought, but an excitement junkie. A tour in the Navy as a shore patrol rating had given him a bit of seasoning, but he still had a habit of tackling jobs the hard way.

Less than five minutes later, he topped a small rise and saw the flashing lights of John's car ahead and a bit closer the white shape of the Mustang. *Funny,* he thought, *it looks like...* The radio crackled. "Heads up, Sheriff, perp pulled a u-ie. He's headed your way. Shall I pursue?"

John swung the Carryall into a sideways skid that blocked the two-lane road and grabbed the mike.

"Come up behind him slowly, you got me, slooowly? He may try another turn and if you are going ass over teakettle he'll either go past you or do a head-on. Be ready to block but don't come so close that he doesn't have time to stop."

"OK, boss."

John pulled the 12-gauge loose from its snap behind the front seat, pumping it twice so the shell of birdshot he kept in the clip for snakes flew out of the action and a full load of double O buckshot took its place in the chamber.

Bracing his elbow against the hood, he aimed the shotgun toward the approaching car, which he noticed with relief was slowing. Gravel crunched against the macadam as the car stopped about 20 feet from John's car. A tousled blonde sat grinning in the driver's seat. She was about forty, not unattractive, but with tanned leathery skin that had seen too much sun.

"Please step out of the car and put your hands on the hood," he called out.

"Wheeee, let's do that again," she called back.

"Step out of the car and put your hands on the hood," he called out again, adding "please" but not meaning it much. He lowered the front sight of the shotgun until it was over the left tire of the Mustang. If she tried to keep running, he'd put a stop to that damn quick.

"OK, OK, you don't have to get pissy about it," she responded, getting out of the car. She was wearing tight pink pants, a pink tube top and shoes with enough heel that John wondered how she had managed to work the pedals. She turned around and put her hands on the hood, leaning much further forward than necessary.

"This what you looking for?" she said, wiggling the pink-encased rear.

With a bit more of a flourish than the situation seemed to call for, Little John arrived, swinging his car so he blocked any potential escape route. John cleared the shotgun, retrieved the buckshot shell from the road, and replaced the gun in its clip.

Five feet from the blonde the wind delivered about a shot and a half of whiskey his way.

"Stay there," he growled to the blonde. "And put that away," to the deputy who had arrived with drawn and cocked pistol.

"I've got to get into town," he said as the now sheepish Rambo uncocked and holstered his pistol. "You can take the bust. Put me down for the assist." This brought a bright smile from the younger man. *Was I ever that young and full of piss and vinegar?* "Charge her with reckless driving, DUI, speeding, refusing to stop..." He paused and followed the younger man's suddenly widened eyes "... and," he sighed, "public indecency."

The pink pants were now around the blonde's ankles while she wiggled her bottom at them. John noticed she was not a "real" blonde.

98

7

When the knock on the door came, Sue and Tom were watching video. Both were lying on the bed fully clothed. Tom flicked off the tv and went to the door. He was not completely surprised to see Sheriff Clarke standing there.

"Come in, Sheriff. I expected you'd be back to finish the interview." He indicated one of the room's chairs and seated himself in the other. Sue pulled together the pillows and sat up on the bed.

"I should probably talk to each of you alone, but I'm really just after one detail that both you seemed to have... forgotten to tell me the last time we talked."

Immediately, Tom said, "I was about to mention the Indian man Sue met in the hallway when our interview got interrupted by the disturbance in the courtyard."

John nodded. "Yes," he said, "that much is true and it was careless of me not to finish up. However, you," he said turning to face Sue, "didn't mention it at all and we didn't have anything happen to screw up our interview."

Sue smiled sweetly. "Sheriff, you mainly asked me to confirm what Tom had already told you. He didn't talk about Jimmy. I didn't see any reason to mention it myself."

"But you're mentioning it now?" John growled.

Sue's expression didn't change, but a bit of a sparkle came into her eyes. "Well, my lord and master has had a talk with this poor little Chinese girl and I'm ready to come clean."

Not wishing to get into a verbal fencing match with this infuriating woman, John turned back to Tom. "OK, no scuffles outside, no banging on the doors. What happened?"

Tom thought. "It was about ten o'clock when Sue brought Jimmy in..."

John was happy to see that there weren't any "significant glances" between him and his wife. Usually, when two people

99

have cooked up a story they can't resist a "how am I doing" glance.

"...the kid was scared but really anxious. She's got a habit of picking up all kinds of strays." At this point, he and Sue exchanged a glance but it was one of affection rather than confirmation. "We don't have to go into details, do we, Sheriff?"

John shook his head. "No, but I do have to know when he left." Before Tom could respond, he held up his hand. "Don't say it." He ripped a blank page in his notebook in half, handed one piece to each of them and followed it with two cheap ball point pens.

Without hesitation, they both wrote and handed back their sheets. Sue had written 4:30 and Tom, 4. John pocketed both pieces, stood, thanked them and left the room.

Tom looked at Sue. "I'm glad that's over."

"So am I. Let's get naked," she responded.

7

"John?"

John looked up from the paperwork on his desk to see Peter Cloudwalker, his chief deputy, standing at the door, a length of fax paper in his hand. Sighing, he motioned the slim man to come in.

"We got word from the LA police," Peter said, settling down in the most comfortable chair in John's cluttered office. "They paid a visit to Ruth Park's attorney and got a copy of the will. It was just as we suspected; Clayton Park is her largest heir. He gets just under twelve mil and control of her companies."

Both men exchanged glances and Peter nodded as John gave a low whistle.

Shaking his head, John said, "That is one hell of a motive."

Peter leaned back in the chair, crossed his legs and replied, "Hell, remember that stabbing last December: the Monash guy who cut up his buddy over half a bottle of Thunderbird?"

John gave a short, sharp laugh. "Yeah, and the bottle ended up getting broken when the guy went over. Anyone else on the list?"

Peter consulted the long sheet. "Next biggest is her brother, Kurt Wheeler. He gets seven million."

John's eyebrow raised slightly. "That ain't so bad either. Better ask them if they can run down this guy and find out if he has an alibi."

Peter nodded, made a mark on the paper with a pen and continued.

"The only other substantial ones are to charities: LA Symphony, American Cancer Society, stuff like that." Peter looked up with a grin that made him look like a teenager. "I don't think the symphony people go in for strangulation."

"Yeah," John snorted, "they bore you to death."

Peter hid a smile. The sheriff's taste in music was well known. "Classical" to him was '50s and '60s country. For the deputy, whose taste ran more to jazz, a long drive with him was an exercise in musical torture.

"There's a bunch of other stuff at the bottom. A thousand here and a thousand there, some furniture and some stuff. I'd say the top candidates are the hubby and the brother. I'm putting my money on the hubby."

John swiveled around and looked out the window. Despite air conditioning and triple paned glass, he thought he could feel the blast furnace heat reflecting from the rocks and sand.

"I don't know. It's kinda funny. The guy has motive, method, opportunity, but he ain't that stupid. In fact, taking into account he's pretty much in a state of shock, I got the feeling he was pretty sharp normally. If he were gonna off his old lady, I'd expect him to try one of those 'Murder She Wrote' things with tons of red herrings and a rock-solid alibi. This is almost too easy."

101

Peter looked thoughtful. "Well, Boss, they all get stupid sometime. If they didn't, we'd be out of a job."

John smiled. "Let's not forget the rest of them. Black was her lover, and that seemed to have ended badly. His 'bosom buddy' Kirkpatrick hates her for sharing Black's cock. Park seems to have beaten up on Burger's wife, so neither of them had any love for her. In fact, Burger made what could easily be considered a death threat the evening before Park got killed. Deerfield was wandering around Roissy about the time of the murder when he wasn't supposed to be anywhere near the place."

He put his head in his hands. "Why do I feel that I'm a character in a bad crime novel?"

"Well, Boss," Peter said cheerfully, "you forgot one other suspect."

John cast a baleful eye on his assistant. "Who?"

"That guy Singletary."

"Fuck, he was locked up in a cage all night in Eva's room. Besides, he doesn't have a motive."

"But, Boss," Peter said with a twinkle in his eye. "You forget that he runs that place for Eva. He greets the guests and supervises the hired help.

"So?" John asked suspiciously.

Peter got up and moved toward the door. "You might say he is sort of a butler. And you know, in those books, it's always the butler who did it."

With his head start, Peter made it to the door before John could get around his desk.

7

Back at Roissy, Eva took another aspirin from the medicine cabinet in her bathroom. She looked at the three tablets in her hand before popping them into her mouth and following up with a swallow of lukewarm water.

102

Strange, she though, I've been groggy all day. I wonder if I'm coming down with something. Then, she shrugged, Hell, with this mess, I may go back to using sleeping pills again. This drew her eye to a plastic pill bottle from the top shelf. She took it down, cradling it in her hand. *Seconal (Secobarbital),* she read silently, *100 mg, one as needed,* and a date just over three years before. Just reading the label brought back memories, bad ones, dreams from another life that had haunted her sleep and sent her from New York to the create Roissy from a failed dude ranch. She shuddered, shook the bottle and paused. Then she opened it and looked in. *I thought there were more,* she thought, closing the bottle and putting it aside.

There was a knock on the bedroom door.

"Yes," she said automatically, turning.

"Mistress," Scum said, entering and kneeling. Even without his accustomed mask and rig, he was holding to his role. "Kevin and Shawn want to leave."

Sighing, Eva said, "Where are they?"

Keeping his eyes low, Scum replied, "They said they were going to their room to pack."

7

Shawn answered the door. "Do you think yer gonna keep us here?" he said before Eva could speak.

"May I come in?" she asked politely.

Some of Shawn's truculence moderated and he stood aside. Half filled suitcases were on the bed and Kevin was standing by the dresser, folding some T-shirts.

Eva walked over to the bed and sat down. "Please," she said, "the Sheriff has asked you to stay."

Shawn opened his mouth to speak, but Kevin silenced him with a gesture. "Flame, we'd like to stay, but frankly this has really bummed us out. I mean, really, we were thinking of leaving when we discovered Park was a guest too, but with her

getting killed and all…" He dropped the T-shirts in a suitcase. "…we just want to get out. You can keep the payment; we just want to be away from this place."

"I know what you mean," Eva said. "It isn't any big fun for me either. I'd like to take a nice long vacation myself. The long and short of it is we can't leave. It isn't the money. Sheriff John has asked us all to stay around."

"He can ask till the cows come home; as for me, I'm leavin'," Shawn said defiantly.

Eva lifted her hands. "He was being nice making it a request. Really, we're stuck here until he decides to let any of us go."

"He can't do that," Kevin blurted out.

Eva shook her head. "He can do precisely that. We are all potential material witnesses," *and suspects*, she thought but did not say. "Actually, he could put us in jail if he wanted to."

Shawn's face turned so white his red hair seemed cartoonish.

Eva saw that and rushed to qualify, "But he won't. He's reasonable, but we've got to be reasonable too." Trying for a brighter note, she added, "If you've got to be stuck somewhere, this isn't all that bad."

The response was distinctly underwhelming, but there was a grudging assent.

Closing the door behind her, she leaned against the wall and held her head. *I'll never get this headache under control.*

7

Kevin pulled on his boots, stood up and turned first one way and then the other, checking himself out in the full length mirror.

"I don't think you should be doing this, Kevin," Shawn said from the bed.

Brushing an imaginary bit of lint from his shoulder, Kevin consciously turned his back on his partner, who was curled up on the bed with his back toward Kevin. Without turning his head, he replied, "I'm not really leaving. I'm just taking a little trip into town. The Pink Sheet said there was a gay cowboy hangout there, and this place is really getting me down. I need a break."

Shawn obviously was fighting to keep a whine out of his voice... and losing. "At least take me along."

Kevin turned and eyed him contemptuously. "You never want to go with me to the cowboy bars in LA. Why the change?"

Shawn looked away.

"Anyway, you don't have anything to wear." Shawn shot the cuff on his tailored tan and black shirt and deliberately put his foot on the bed next to the naked man, giving the hand-tooled snakeskin boots a quick whip with one of Roissy's towels. Shawn stayed in his semi-fetal position so Kevin reached down and fondled his backside.

"Just think, I'll come back here all nice and horny and we'll play a bit." Kevin peeked over his lover's hip to see whether his cajoling was having an effect, but the flaccid cock didn't respond. Kevin's voice became more conciliatory. "I'll spank you nice and hard and let you jerk off while I fuck you in the ass." The organ remained refractory. Quick anger flashed on Kevin's face. He gave the butt a quick slap. "Well, do what you want."

Shawn sat up and swung around. " 'Do what you want' is it? That should be your motto. It should be tattooed on your forehead. 'Do what you want.' That's you. You run off and fuck other guys." Tears were beginning to glisten in the blond man's eyes. "You even fucked that bitch, Park." He shook his head and a few droplets flew off. He drew his arm across his eyes to clear them. "I'll bet you were thinking of fooling around with her." His eyes got wide. "Why were you wandering around after I went to sleep? Were you going to meet with her?" Shawn drew

105

back, his testicles drawing themselves up against his crotch. "Did you meet her?"

"I don't have to stay and listen to this," Kevin said defiantly. He walked out the door, slamming it behind him. He didn't meet anyone on his way to the courtyard and the Jeep started with the first turn of the key. He reached for the headlight switch, but then shook his head and drove out the gate steering by the light from the building's windows. Only when he was halfway to the highway did he turn on the headlights.

7

Eva heard the car start over the sound of the television in her private quarters. Her first thought was that Scum was making a run into town for some supplies, but when a glance at the bedside clock showed it was past ten, she went over to the window in time to see the Jeep Wagoneer pull through the gate. "Fucking stupid sons of bitches," she muttered under her breath. Her hand went to the phone, but she stopped and went out to the message board next to the exit. Nothing. Then she went down the hall and tapped on the door of Kevin's and Shawn's room. No response. She was just about to head back to the office to make the call to the sheriff when she heard a low sniffle. She leaned close to the door and could make out the sound of what sounded like muffled crying.

She knocked louder and called out. "Kevin, Shawn, it's Eva. Let me in." A bit more knocking, louder, and another request plea got no further responses. With an exasperated shake of the head, she went back to the master key panel in her room, got the copy of the room key and, returning, let herself in.

Shawn looked up from the bed, red eyed. He wiped his nose, then said, "I'm all right."

Eva looked around the room. "Where's Kevin?"

That set Shawn into a fresh run of sobbing.

Eva thought she made out "He's gone" amid the blubbering.

"Where?" she snapped, a bit more harshly than she intended... but her mind was preoccupied with worry she should have called John the minute she saw the taillights of the car pulling out. If he says LA, she thought, John may still be able to nail him. If not, the Staties will have him before he gets to the border.

It would have taken the full cryptographic resources of the NSA to completely decipher what followed, confounded as it was by tears, sobbing and Shawn's propensity to bury his face in the pillow, but she managed to make out "Pizzle" and "Club."

"He's going to the Bull's Pizzle in town?" Eva asked. Shawn didn't reply, but the look he gave her was that of a man feeling the wet grip of quicksand closing over his chin. This quickly changed to befuddlement as the red-haired woman leaned back and roared with laughter.

7

The Bull's Pizzle, often shortened to "The Cock" by its present habitués, had started as a speakeasy during prohibition. With the lifting of the ban on hard liquor, it had not flourished since more convenient and attractive enterprises had sprung up within weeks of the end of The Great Experiment. For a while, it limped along supplying indifferent booze to truckers and transients. Eventually, it added other, more intimate, services supplied by hard-eyed women who lacked the assets to attract a more discriminating clientele. Eventually, the forces of law and order descended, leaving it empty until a pair of quiet, hard-bitten men bought the place, renamed it and settled back while the word spread that a certain kind of manly good fellowship was available within its walls. Townsfolk might speak of it with a suppressed giggle or a glare, depending on the

individual's level of moral outrage. Several times, when one of the more outraged individuals happened upon kindred spirits, the "good citizens" made a bit of a field trip "to teach the queers to mind their own business" with baseball bats and tire irons. The fact that the "queers" in question were indeed minding their own business didn't seem to make much of an impression. However, the fact that a number of these "kindred spirits" made their return trip to the center of town in the local ambulance did make a significant impression and eventually the narrow of mind limited their outrage to oaths and curses... spoken softly.

At the time of its founding, The Cock was well outside of town. As the town grew, it swallowed the small building like a nearsighted amoeba engulfing a bit of dirt, but like the dirt, The Cock was pretty unpalatable. It had been isolated by a collection of warehouses, slaughter pits and other accessories to civilized life to the extent that Kevin had some difficulty in locating it, but he wasn't surprised. Even in the Big City, gay bars largely depended upon word-of-mouth rather than flashing neon to attract customers.

But now, Kevin had the feeling he had made a mistake. In LA, his expensive boots, country-and-western shirt and designer jeans would have fit right in. Here, he felt like Gene Autry transplanted into a Sergio Leone spaghetti western. Instead of mock grunge and trendily dressed down suburbanites out for a night on the town, this place had an air of real grime and, at the bar, a dozen or so rough-looking men sat on bar stools. Most disconcertingly, all were facing away from the bar, most leaning back on their elbows, looking directly at the door... at him.

Kevin moved sideways toward the unused pool table. He made a great show of taking down a pool cue and sliding it through his hands and then looking down it. Out of the corner of his eye he saw that the collective gaze had not wavered. Turning his back on the bar, he took his time returning the cue to the rack. Hoping that someone else would walk through the

door... that something would distract the crowd at the bar. He was used to being in command or, at least, anonymous. Here, he felt like a mouse at a cat convention.

"You!" The word cracked so loudly that Kevin involuntarily jumped. This produced a muffled laugh from behind him. He turned. It was obvious the call had come from a heavily muscled, mustachioed man near the center of the group at the bar. The man was leaning forward, his arm extended, finger crooked. When he saw he had Kevin's attention, he said, "Over here, boy," and put down his arm confidently.

"Who you calling a boy?" Kevin replied in what he had planned to be a confident, macho voice. He was a bit surprised when it came out with a touch of quavering tenor.

Looping his thumbs behind his belt, largely to keep his hands from shaking – this was not like the cowboy bars he was used to – he walked across the room.

"What's yer name?" the man demanded.

Kevin looked him in the eye, took a better grip of his belt and said, "Kevin."

"You queer?"

In for a penny, in for a pound, Kevin thought, noticing however that the compressed leather of his belt was making a disconcertingly loud creaking as his fingers compressed it. Besides, this was not the time to discuss the merits of bisexuality. "Yeah," he responded. *"You* queer?"

The big man leaned back on the bar and let out a barking laugh. Suddenly, Kevin was surrounded by the formerly menacing crowd, all of whom seemed to want to slap his back or shake his hand... usually with a grip that threatened to rip the appendage off.

When the crowd had quieted, the big man held out his hand and said, "I'm Pete, head drover for the Circle Star." When Kevin took it, he continued, pointing to his left, "This is Road Warrior, one of the long haul truckers who come through from time to time; next to him is Mike, who works construction

109

hereabouts..." He continued with Kevin acknowledging the intros with waves and nods.

When the intros were done, Pete looked Kevin up and down with a half smile. "And what brings you to this little backwater? I'd say you'd fit in better a bit closer to Castro Street."

Kevin smiled sheepishly. He wondered if he'd ever feel comfortable wearing this rig again. "Make that Figueroa, and you'd be right. I'm staying out at Roissy, and the Pink Sheet said there was a gay cowboy bar in town."

Pete leaned back and gave another of his barking laughs, joined by a few of the people who had gathered around. "And you thought it was a fern bar with a few sheep skulls on the walls for atmosphere."

Kevin felt his face growing warm. "Well," he gestured, "this wasn't exactly what I had in mind."

This earned him another laugh and a slap on the back that almost knocked him off his feet.

"Son," he bellowed. "This is a *real* queer cowboy bar, 'cuz we're cowboys, or as close to it as you get in this pussy day, and by god, we're queer."

This was greeted by a hammering of beer mugs and glasses on the bar.

For the first time, Kevin noticed the barkeeper. The little man in a vest and white shirt had been completely overshadowed by his customers. It was only because he had come up behind Pete and asked diffidently, "Would the gentleman like a drink?"

Pete grabbed Kevin by the shoulders and turned, almost slamming him against the battered mahogany edge of the bar. The men next to him edged sideways a bit, giving him breathing room.

"What'll you have, pardner?" Pete said.

Kevin was about to order Johnnie Walker Black on the rocks when he realized The Bull's Pizzle was more likely to have dancing girls in spangled tights. Quickly scanning the

110

nondescript bottles behind the bar, he fell back on a standby of his college days. "Beer," he ordered in a hoarse voice.

Without inquiring about the brand desired, the little bartender scooped up a large mug from an untidy pile and filled it with a brown liquid from a British-type handpump. Setting it in front of Kevin, he said, "Two dollars, sir. Would you like to pay now or run a tab?"

Pete reached out and swept the mug toward Kevin who caught it before it could crash on the floor. "Put this one on my tab." He smiled at Kevin. "You can get the next one."

He leaned back and took a draw from his mug and then turned to Kevin. "Rumor has it that Eva's sittin' on a cactus out at Roissy." Nobody at the bar made an overt move, but Kevin could sense that everyone was listening carefully.

"You could say that," he said. "There was a murder." He paused, waiting for a response, but Pete just silently looked at him. "A woman, name of Ruth Park, got killed." He waited, longer this time, wishing for some excuse to change the topic. Finally, Pete spoke, his voice gentle with a touch of steel behind it.

"Son, I don't know how things are in LA, only went there once and didn't much like it, but around here, we respect a man who tells a good yarn." A few mugs got banged on the bar. "If you're gonna keep talking like you gotta pay by the word like a damned telegram, we won't be getting off on the right foot." Louder bangs, more mugs.

Kevin looked at the crowd. He didn't feel any outright hostility but he could feel that he was still being judged. Oddly, he wanted to fit in. "Let me get some of this beer, boys; talkin's dry work," he said copying Pete's style of speaking. This got him another slap on the back.

As he told the story, he could feel the group around him warming with a few shouts and mug bangings as counterpoint. He carefully left out his relationship with Park, still not know-ing how bisexuality would be received by his audience. His

mug was refilled regularly by the bartender with one or another of the audience yelling, "Put it on my tab."

Finally, by the time he finished, a number of the patrons had left their seats and were clustered around the section of the bar where he and Pete were sitting. "And that's about it," he said.

"Damn, sounds like John's got his hands full with this one," the construction worker, Mike, said.

"Just as well. Maybe it'll keep him from hassling regular folk," Road Warrior said, getting a round of laughs and catcalls.

"You're still pissed because he got you hauling a load of steers that weren't rightly yours," Pete said, drawing a glare from the trucker. "The Sheriff's been pretty even handed around here."

For the first time, the bartender piped up. "I'll say. They kept closing this place down with every lie and excuse they could come up with when Barlow was sheriff. John doesn't put up with any nonsense but he's fair." This earned another round of mug banging. Kevin began to realize why the glass mugs looked so battered. Slamming them down on the oak bar evidently was a second language around here.

"Damn, I didn't know those beefs weren't legal," Road Warrior protested, "Them Indians just paid me to haul them." This drew another round of laughs. Clearly, Road Warrior's dispute with the sheriff was standard fare at the bar. He looked around defensively, his lower lip protruding a bit, and withdrew to the bar's end, waving his almost empty beer mug at the bartender.

"Sheriff's a nice guy," Pete said, half to himself. "I kinda wonder if he ain't a bit queer himself."

"You're kidding," Kevin asked. "He ever come in here?"

"Sure, he's in here a bit," Pete said, "but always on business. Still, a man can hope, can't he?" As he said the last, Pete turned an appraising eye on Kevin, who suddenly remembered that this was, after all, a gay bar.

Pete was definitely not his type. He liked them skinny and weak, like Shawn. He liked to be in charge. This was not his kind of place. He'd leave now.

When Pete got up and walked toward the back of the bar, Kevin was surprised to find himself following. He had expected Pete to turn at the door marked "Gents," but the big man walked past it and pushed on an unmarked door at the end of the corridor. The room on the other side was spacious and significantly cleaner than the barroom itself. It had several mattresses on the floor and to Kevin's surprise, a number of chains hanging from beams in the ceiling.

He was about to explain to Pete that he was a top and liked smaller men and to graciously explain that Pete wasn't his type when the big man turned around, reached around to the back of Kevin's head and pulled him close for a kiss.

It had been a long time since Kevin had kissed a man with a mustache, a professor at college who had taught him a lot more than English Literature, but it all came back in a flash and, with it, the youthful passion. His tongue greeted Pete's, and his hands found themselves stroking the front of the man's pants.

The next thing Kevin knew he was kneeling, his face in one of the mattresses. Pete's mouth was close to his ear as he heard, "This might smart a bit, Kid," and suddenly he felt himself almost split in half. However, just as his throat screamed, he felt his body driving back, trying to capture the invader, surround it, make it part of him.

Finally, he was lying on his stomach, feeling somehow incomplete, empty. He could hear Pete moving around, clicks and clanks. Kevin knew it had something to do with the chains but turning his head seemed to be too much trouble. Then he was lifted, effortlessly in strong arms. Above him, Pete smiled down.

"Now, it's time for you to have a bit of fun," the man said, and put Kevin down into a sling suspended from four of the chains.

113

"Fun?" Kevin said drowsily. Then, he felt a Crisco-slick finger enter his ass. It was so tiny, so small, that he welcomed the second and third.

"I've never done this," he said wondering if it was the beer or getting out of Roissy or maybe Pete, but he was feeling vague, and good and ... "My *god!*" he screamed and arched as he felt the hand completely enter him, his sphincter closing tightly over the man's hand. It hurt, it hurt good, it hurt very very good... and then a knowing finger found his prostate and another slick hand closed over his cock, gently pumping it. Whenever he came close to cumming, the finger pulled away from the prostate and the hand slowed.

It was sort of a sensual agony... a voluptuous purgatory. It seemed right that he accept the cock that brushed against his cheek, sucking it as he liked Shawn to suck his, smelling the manly musk and finally accepting the rewards of his effort. Then another cock was there, demanding, and he welcomed it. Hands touched him. Pinched his nipples. Stroked his neck. Many hands, all at once. He wondered how Pete was doing all this. How could one man... and then it didn't matter. The orgasm seemed to start at his toes and blast the top of his head off. The hands lifted him from the swing, and he felt the mattress again under him, a blanket, he pulled it tight and slept.

7

Shawn was asleep in the bed when Kevin got back to Roissy. Gently, he pulled away the sheet and began to suck Shawn's cock, wondering if the world had really changed as much as it seemed.

TUESDAY. John's phone rang three times before he answered it. Doc Barnes was on the other end. He sounded puzzled. "John, I just got back the tox report from the State Police lab; actually, I got back two. One for each of the Parks."

John grabbed a pen and a pad. "Go ahead. What did they have in them?"

"Well, Ruth Park looked like she had been tasting her way through a pharmacy. I've got trace amounts of uppers, downers, coke and even what might be a touch of heroin. However, the only things in her system that might have had a significant effect was angel dust and a big jolt of Secobarbital."

"Seco-what? Spell that out for me, Doc," John said, puzzled.

Barnes spelled it and added, "It's a powerful sleeping pill. Figures, in a way – with the angel dust in her system she wouldn't have been able to sleep, so she pops another pill and it's dreamland."

"Same with Clayton?"

"Nope, that's the odd thing. There's a little spike for angel dust, but it's the sort of thing you'd expect for someone who had been around where a lot of it had been snorted. He's clean on everything else, except..."

"Except," John repeated.

"He evidently took an even larger dose of Secobarbital than she did. No wonder he fell asleep. He'd have nodded off at the Grateful Dead concert."

"Druggies," John sighed. "Bring the report over when you can, Doc."

He hung up the phone carefully.

"Druggies," he sighed again. Then, he paused. Clayton Park had not seemed the type.

At that point, there was a banging on John's door. Before either man could respond, a portly man pushed it open and stepped into the office uninvited. "Clarke, we have to talk," he said without preamble and seated himself.

Peter looked at John as the latter, his face held perfectly neutral, gestured toward the office door. When Peter had closed the door behind him, John said, "What can I do for you today, Counselor Rosario?"

"I'm here about what happened at that 'place' out on County 21. I presume you'll be closing it down now." The self-satisfaction in the councilman's face was almost a visible glow.

John slowly shook his head. "We're investigating a murder that took place out there. I don't see any reason why I'd close down Roissy."

Rosario's jaw tightened. "We've talked about this before. It's a shameful place and now one of those perverts has killed someone."

"Yes," John said softly, "We have talked about this before. What they are doing is perfectly legal. You checked with the state attorney general; you know that."

"But damn it, man, there's been a murder there!"

"Councilman Rosario, there was a murder at your cantina last year, and if I'm not mistaken, one or two years before I took this job. Should we close you down?"

The flush that had been growing in Rosario's face spread downward toward his collar. "You know that isn't the same," he almost shouted. "It is a house of prostitution!"

As Rosario's voice rose, John's became more soothing. "You know that it isn't. We had a long investigation when it opened. You even had the state cops come in and do their own. It is no more a house of prostitution than the Holiday Inn out by the Interstate."

"I'm responsible to my constituents, and they want that place closed down," Rosario said with the air of a man slapping down a royal flush at a poker game.

"We've been around on this again and again. I'm responsible to the same constituents. I get elected every two years same as you do. I don't see most of them getting worked up about it."

"Listen, Clarke, no decent person wants to be associated with those perverts. You've been shielding them and that gang at the queer bar for years. I have a decent family; I've raised my kids right. If you can't tell the difference between those kind of people and a bunch of perverts, maybe you aren't the kind of person we need in this office."

Clarke's voice had a bit of an edge. "I've got news for you; as far as the law is concerned, there isn't any difference between your family and 'those people.' Nobody is getting special treatment, but nobody is going to harass legal businesses in my jurisdiction either."

"Legal, legal, is all that you care about? If something is legal?" Rosario said vociferously and leaned back, obviously feeling he had scored a point.

"Yes," Clarke said mildly. "I'm a cop."

"What about moral?" was the counterthrust.

"I have my morals; you have yours. That's the nice thing about this country; we can disagree."

A poisonous grin spread across Rosario's face. "Well, I've been talking to Father Benavides. He's not happy with the way you've been getting buddy-buddy with those perverts either. I think you aren't going to like the homily next Sunday."

Clarke raised his hands in a gesture of acceptance. "It's his right, but I've noticed he's been raising hell about birth control

117

and divorce since I got here, and it doesn't seem to have affected the condom sales at the drugstores much."

With a heave, Rosario lifted himself to his feet. "You haven't heard the last of this," he said heading for the door.

"Give my best to your family," John said, as Rosario slammed the door.

"John," he said quietly to himself, "that was beneath you." And then he grinned.

7

"We gotta give the LA cops credit, Sheriff," Peter said. "They've really been cooperative in this Park thing."

Peter had greeted his boss as soon as the big man had come into the door from the evening rounds. John walked over to the other man's desk, swung a chair around, and sat down resting his forearms on the back.

"Wadda we got?" he said, glancing at the yellow pad on the desk that was covered with Peter's handwriting.

"They tracked down Ruth Park's brother and he's got an alibi. Boy, has he got an alibi."

"He dead?"

The deputy laughed, "Almost as good; he's in India."

"India? What the hell is he doing in India?"

"He's getting his transendentled meditated or something like that. According to the detective LA assigned to the case, about a year ago Kurt Wheeler got what passes for religion in the Big City and joined some kind of cult. About six months ago, he flies off to this place." Peter held up the pad, finger on a word that seemed to have a disproportionate proportion of vowels. "I'm not even going to try to pronounce it.

"They checked with his office and he's still there..." Peter made a face. "...seeking enlightenment."

"Probably smoking dope," John snorted. "We get anything else of use?"

"Lots of negatives. The detective did the usual walk round. No whispers of any specific threats. He did say that Park was about as popular as a porcupine at a nudist convention. She's made a lot of enemies, but nothing that pops off the charts."

Peter paused, lifted his pad and read carefully from it. "The guy said, 'She made Attila the Hun look like Mother Theresa.' Wow!"

John thought back to his interviews out at Roissy; he nodded his head and said, "That's probably an understatement."

"Oh, one thing more. They went through the Parks' place and they'll want to talk to Park when ... well, maybe, if... he gets back. They found a stash of coke and angel dust in the bathroom."

"Major?" John asked.

"Nah," Peter waved a hand dismissively. "They aren't talking about 'intent to sell.' The detective said that they probably wouldn't have even looked twice." He smiled. "After all, it is LA. But it was part of an official search so they had to bag and tag it. Did you find anything in their room at Roissy?"

"Nada," John said, "but Clayton had plenty of time to ditch it. Eva didn't secure the room or anything. Doc Barnes told me earlier that both Clayton and the stiff had heavy doses of sleeping pills in their systems. I'm not surprised that they keep stuff at home..." John paused thoughtfully. "Call the detective back and ask what kinds of prescription drugs they had around the place."

7

Dr. Amos Kaul was proud of his crew at the University of Arizona. In less than a year, they had found a way to do genetic analysis and comparison that was orders of magnitude faster than the conventional methods. Now, all that remained

was to refine the techniques to a level of reliability that would make it acceptable to the courts. Therefore, he was overjoyed when a series of skin scrapings came in by FedEx from a rural doctor involved in a local murder. Even better, the enclosed note had said that matched samples were on their way to Quantico. Coming up with the same results as the FBI lab, but coming up with it first, would be further substantiation that his method was valid.

He had pulled one of the post-doctoral fellows off some tangential research and put her to work with the matching. Now he wasn't so happy.

The young woman was nervous and showing it with rapid speech and a shrill tone. "We got a solid match with the tissue from under the nails, but then I noticed that these two samples were also matches, but they are supposed to be skin samples from two different people. I'm sure I didn't mix them up. I followed the protocols to the letter."

Kaul looked at the two printouts. They certainly seemed identical. To the untrained eye, they looked like magnified versions of the scanner labels used on food products. Narrow and wide lines marched down the sheets of fan-fold paper with a jagged line running over them, but they were actually maps of the links between the twin spirals that made up the DNA molecule.

He hid his displeasure. The bright young woman had the annoying habit of letting her voice climb into the supersonic reaches when she was agitated. He had just returned from a walk across campus, and the sun had given him a mild head-ache which was slowly fading. The last thing he wanted to do was aggravate it.

"It could have been a number of things, Susan. That country doctor might have mixed up the samples himself and mislabeled the tubes. He might not have cleaned the tool, and what we are reading here is a cell that was left behind from the previous donor. I'm sure..." He paused, looking at the printouts more carefully. "Wait," he said, intently. "Look here," he

pointed with his Cross pen and circled, "and here." Another circle. "And here."

He passed the printouts back to Susan. She looked at them for a moment and flushed. "But they..." she started to say, but Kaul cut her off.

"They look alike," he finished for her. "However, they are clearly from different people." Mixed emotions made is voice sharper than he had intended. With a conscious effort, he moderated his tone. "Susan, you do wonderfully creative work, but on the routine things, you can be a bit..." He sought for a word. "...uncritical. Just because this is routine, doesn't mean you shouldn't give it your full attention."

"But, Doctor..." As he had feared, the "bat squeak" had crept into her voice and drove an ice pick into the sun-spawned headache all the way to his medulla oblongata. He held up a hand to silence her.

"It isn't really a major failing. Your greatest strength is in research. I shouldn't have used you as a lab tech. Why don't you finish this up, give me the report, and then go back to that project I pulled you away from. I'll take it from there."

Placated, Susan thanked him, moderating her tone to a degree, and the ice pick withdrew until it was only resting behind his left eyeball. Kaul sighed as the door to his office closed.

122

WEDNESDAY. Doc Barnes stopped dead in his tracks. He had hurried over to the Sheriff's office and had not bothered to knock on John's door. But the look in John's eyes when the big man looked up from his desk would have made a charging rhino have second thoughts. The look vanished as fast as it had appeared. John waved the Doc to a chair and said apologetically, "Sorry, it's been one of those days."

Barnes draped his lanky frame into the straight-backed chairs that was closest to desk and dropped a fax onto the man's desk. "I deliver," he said with a flourish.

"What's this?" John asked.

"I said I'd get you a DNA match and I got you one. Afraid there ain't any big surprise in it. The skin under Park's fingernails was her husband's."

"Well, that ain't worth shit," John said resignedly. "He's already said that she scratched a lot during sex so the gun ain't smokin'. Funny thing, Doc. I've just got a real strong feeling he ain't the guy."

Barnes spread his hands. "Can't make salsa out of cow shit. What you got is what you got." Then, he paused. "Don't know if this means anything, but there was something odd in the report."

"Odd? How odd?"

"Well, two of the skin samples almost matched. I got the feeling talking to Kaul up at the university he suspected that I'd contaminated the batches, but there wasn't a chance of that. Besides, the two samples were taken at two different times because I did all the guests at one time and then had to track down everyone else."

"What are you talking about, Doc?"

"Well, Ruth Park and that servant, Scum, have real close matches." He gestured vaguely. "It can happen. No two people are identical but there are only so many combinations. Usually if I saw a pair of profiles like that I'd think they were mother and son or ..."

The look in John's eyes stopped him for the second time.

John said slowly, "Or sister and brother?"

Barnes nodded; John grabbed for the phone.

The ringing seemed to go on for forever, but then Eva's voice came on the line.

Without ceremony, John demanded, "Where's Scum?"

"He's cleaning my quarters," Eva responded, a puzzled note in her voice.

"Keep an eye on him, Eva. I'm coming right out."

"John, what's up?"

"Listen carefully, Eva," John said, "I've got pretty good evidence he's the one who killed Park."

"Scum?" disbelief was evident in Eva's voice. "Why in hell should he do that?"

"A couple of million reasons," John responded. "I think he is her brother."

"Shit," Eva sighed. There wasn't much else she could say. "I'll watch him until you get here."

"Be careful."

"I will."

Lowering the phone to its cradle, Eva sat absolutely still and then opened her drawer and took out an old 9mm police automatic. She put it down on the counter, picked up a clip and began to load it with rounds from the drawer.

124

7

Kurt Wheeler, the man everyone at Roissy had known as Scum, carefully put the phone down. What had started as idle curiosity, buffered and reinforced by supreme confidence, became terror. How in hell had they found out? he thought. But that didn't matter. What mattered was that damned mountain-sized sheriff was coming for him, and he had to get away.

The only way out of Flame's quarters was through the office, and she was there, alerted. He opened a window and started to slide through it. The rack of rifles on the wall caught his attention. Pulling his leg back inside, he went over to it. The rack contained six or seven various sized firearms including several with telescopic sights. Kurt grabbed the smallest and went out the window. His motorcycle was just where he had left it three months ago. A quick series of taps on the tank confirmed he had plenty of gas. He slid the rifle over the top of his saddle bags, mounted the bike and fired it up.

7

Eva heard the roar through the thick adobe walls, but didn't realize its source for a few seconds. By the time she made it to the window, there was only slowly setting alkali dust in the courtyard and the roar was rapidly diminishing in the direction of the highway. She ran to the gate and watched as the motorcycle turned left and accelerated away on the paved road. Then, she dashed back to the office and dialed the sheriff's office.

Lois informed her that John had just left. "He looked like he was in a big hurry, dear."

"Patch me through to his car radio."

125

Lois was in a coy mood. "Now that's for police business only," she responded. Then she lowered her voice in a conspiratorial manner. "Besides, dear, then everyone with a scanner can hear what you two are saying. Maybe you should...."

Eva cut her off. "There is a murder suspect headed north on County Road 21, and John has about half a hour to cut him off before he's gone... maybe for good."

Lois' attitude vanished. Eva heard her say, "Base to Sheriff John. Important message from Miss Hernandez, wait one." In a few seconds, there was a crackling response that the phone's handset couldn't transmit intelligibly and then John's voice came through clearly. "What's up, Eva? You got problems there?"

"Not really my problems, John, but you better act fast. I think Scum.. Singletary... oh, hell, whoever he is, may have been listening on the extension in my quarters. He's jackrabbited. Last seen on a motorcycle headed north on 21." Eva realized her voice was becoming clipped, professional, detached. A bit to her surprise, she enjoyed it. "Motorcycle is a black Honda Goldwing. Year unknown. Suspect is wearing a red and black linen shirt, tan pants, black helmet and jogging shoes."

Another voice broke in on the circuit. "Sheriff, what's up? I'm on 21 near the mesa."

John spoke up. "Great, John, take up a blocking position and wait for him if he runs straight. Remember he's on a motorcycle so pick your spot so he can't go around you." Then he added, "Suspect is wanted on a murder charge. So be careful. He's probably not armed but we don't know."

"Peter, are you listening in?"

Eva listened as John gave his deputies directions to block all the potential escape routes from that end of the county. The long cord gave her enough freedom of movement to be able to look into her living quarters. She saw the open window. Then, then she saw the rifle cabinet.

126

"John," she said sharply. "Suspect is armed. There's a .30 caliber carbine missing from my gun cabinet."

John's tone didn't change. "Did everyone hear that? Check in by unit and confirm. Suspect is armed with a long gun."

One by one each of the deputies responded.

"Thanks, Eva," John said. "Little John," he continued, "I'm headed up 21 toward your location. ETA twenty minutes. Look sharp, everyone. If he turns off 21, he'll be headed for one of you. A Goldwing is too big and heavy to do much cross country work, so he's going to have to stick pretty close to the road."

Eva hung up and sat down at her desk. After a few minutes, she got up, walked into her living room and looked at the empty space in her gun rack.

She heard the wail of a police siren waxing as it approached her and then waning as it passed and continued down the road.

7

Wheeler was beginning to feel better. Better, of course, in a relative sense. All the planning and work that had gone into what he thought of as his "retirement" plan was up in smoke, but he was free, and in a few minutes, he'd be at the interstate heading out of this hick desert. His absolute terror of Sheriff John had transmuted itself into a smug satisfaction. Sure, the guy was as big as a house, but bigger didn't mean better. He was probably stupid as one too.

Catching on must have been pure luck. *I had it all planned. Sis had bragged about how much she paid to visit kink central out here in the desert. It was perfect. With the mask she never recognized me, a bit of nighty-night powder in a few drinks made sure everyone was sleeping soundly and Flame's precious backup key got me right out of that damned cage.* He jerked the motorcycle to one side to miss a bit of unrecognizable roadkill. Falling now would ruin

everything. He moderated his speed a bit... just a bit. Gotta get out, but gotta get out in one piece.

He quietly laughed to himself. *God, her face when I took off the mask. She thought it was all a joke... at first.* He could feel his erection growing. *I guess it's every boy's dream to fuck his sister. She was good. Toward the end, when I pulled the rope real tight, she was bucking like a Bangkok whore.*

Heat rising from the pavement made images dance, but there was no mistaking the flashing red and blue lights about half a mile away. Damn, piss, fuck. He started to turn the bike around; then, he remembered the miles back to Roissy. Not a single side road. He had to keep going. How?

Then, he saw it. A pair of tracks leading off toward the big bluff.

7

"Sheriff, Sheriff," the radio blared. "This is John on 21. I just saw a black motorcycle and rider head up Lawson's trail. Should I pursue?"

John thought for a moment and said, "Are you in a good blocking position now?"

"Affirmative. I'm right over a culvert. Got dry washes on each side."

"Hold your position. He may be planning on pulling off the road and letting you go by. Peter, he's past you now, so run over to 21 and head north. I'll go in after him. If he pulls that stunt, you and John will still have him in a sandwich. When you get to Lawson's trail, block it. Nobody in or out. Got me?"

"Right, Sheriff," both men responded so closely together that their transmissions overlapped.

9

It's gotta come out somewhere, Wheeler thought. The road, if you could call it that, was little more than two depressions worn in the rocky alkaline soil. At first, the motorcycle made good progress, but as he had to repeatedly slow down, it became harder and harder to control. In the city, roads, even alleys, usually led somewhere. He had figured this track would eventually swing back to the main road or led him to another one. Instead it was twisting and climbing, seemingly with no proper destination in mind. Just as he was about to give up and head back, the ground to one side of the road dropped away and he saw that he was now parallel to the roadblock. Just keep going in this direction, he thought, and I'll come out on the other side.

The bluff, or whatever it was, was impressive this close up, a huge slab of lichen-covered black rock lined with splits and cracks. Wheeler looked up, his eye drawn toward the top. At that moment, the motorcycle jumped under him, a terrific crack coming from underneath. *Gotta keep your mind on the road,* he rebuked himself and increased speed a bit, picking out a path through the increasingly large rocks that studded the ground, even between the tire ruts.

On the left, he could still see the police car's lights clearly through the heat haze, but Wheeler was pretty sure that the cop couldn't make out something as small as a motorcycle at this distance and through the dancing images caused by the rising heat. He never looked back to notice the plume of dry dust his tires left hanging in the air... a plume somewhat reduced by the black spray of oil coming from the cracked crankcase.

The trail was still slanting upward, but it seemed a bit smoother and firmer, rock rather than sand and dry soil, so Wheeler gave the throttle an experimental twist and the speedometer crept upward close to, and then past, thirty. It

may have been one cylinder, robbed of oil and overheating, or the bearings in the crankcase, but while the cause was in doubt, there could be no mistaking the effect. The smooth roar of the Honda's engine became an ear-splitting "bang," and the rear wheel went as immobile as if it had been welded into place.

The resulting side-skid sent the heavy motorcycle leftward toward the edge of what was within a few degrees of being a cliff. Wheeler automatically jumped right and clear; then, realizing what had happened, dived for the teetering bike, which had stopped with its rear wheel already over the edge. Stopping the front wheel by grabbing the hand lever right handlebar, Wheeler stopped it from going completely over, but the motorcycle was heavy and his strength was insufficient to bring it back to solid ground.

Finally, accepting the inevitable, he reached toward the saddlebags with one hand, pulled loose the rifle, and reached inside. However, as his hand closed on a dusty water bottle, an inch or so of the roadway crumpled. By itself, that was insignificant, but the motorcycle settled just a bit, just enough so that the center of gravity was moved outward away from the ground. Wheeler was just able to jump free as the motorcycle swung backwards and up, the handlebar catching him a crack across the forehead that could have been serious if he hadn't been still wearing his helmet. Then, as irrevocably as an avalanche, it fell, bouncing on rocks and outcroppings until it came to rest in a cloud of dust. No movie-style explosion, just fate, as final as that handed down by a black robed judge and carried out by an unseen hand on an electrical switch.

Wheeler stared over the edge for long seconds and then unstrapped the helmet and flung it after the motorcycle. He retrieved the rifle and, taking a sip of warm, flat water, began to walk.

7

Wheeler had been wrong. John at the roadblock could see him quite well. This was made possible by a pair of 8x35 binoculars he had bought as a Christmas present for himself last year at a local pawn shop, and by the fact that heat currents do most of their distorting near the surface. Up higher, away from the hot soil, the air is less roiled and light has an easier passage.

John was raising his microphone to update Little John when he saw the red and blue flashes approaching. He waited, and when the approaching police car passed the entry of Lawson's Trail, he put the microphone back in its clip.

Little John slowed and came to a controlled stop a few feet from John's car. Little John was constantly surprised at how composed the Sheriff was. He knew that had he been in that car he probably would have broadslid home in a cloud of dust. It embarrassed him constantly, but he somehow couldn't control it.

He swallowed and consciously put on a professional demeanor as he walked over to his boss's window. Mental rehearsal made his first words come out exactly as he wanted them. "Suspect is now on foot. Only a minute or so ago, I saw his bike go over the edge near that Y-shaped rock formation. At first, I thought he went with it, but I then observed him stand up and continue down the trail. Shall we pursue?"

John mentally brought up a map of the area and took note of his watch. "I'll go up after him, but that's pretty rugged terrain and he could hide pretty easily. Here's what I want you to do. Follow me up the entrance of Lawson's trail and call Jeff in town. Have him load up his horse trailer and bring them out here. Call in the rest of the deputies and have them meet you and Peter at the trail head. You stay with the cars while the rest of them move up until it gets dark. Tell Jeff to bring bedrolls with the horses. This may be a long one."

131

"Why don't you leave one of the other guys here, Sir."
Little John blurted out and then mentally kicked himself, but
John didn't seemed upset.

"John, you're new out here. Give it time. Some of these
guys like Peter were almost born in the saddle. This may be a
tough ride over some very rugged territory. Besides, I need
someone reliable here. There's a good chance this guy will give
up and head back this way. He doesn't know the area and this
is the one section of the trail he's even seen once. I don't want
someone who'll go to sleep under that tree over there while he
slips past."

John shaded his eyes and looked south. "Speaking of Peter,
I think I see him coming. Get on the radio and make the ar-
rangements. I'm going to keep this guy off balance if I can."
With that, he swung into the Ford Carryall and headed back
toward the trail.

7

As the shock of what had happened wore off, Wheeler
began to realize just what a bind he was in. With that realiza-
tion, he sat down on a rock and cried. Then, a different aware-
ness took its place. He might be facing possible death in this
rocky furnace, but if the cops caught him, it would be certain
death. *It's trite but true*, he thought, *I'm not going to be taken alive.*
The weight of the rifle in his hand gave him confidence. He'd
never fired or even held a gun before, and the weight had
surprised him, but it was a comfortable weight, one that made
him feel powerful.

He headed along the trail in the direction he had been
going. If the trail didn't loop back to the main road, he'd climb
down when the slope got more gradual and make his way
across country to the road. Maybe he could hitchhike. He
hefted the rifle. Hell, once I'm out of sight of that cop, I'll take
what I want. But, the trail didn't curve back toward the road

132

and the slope became sharper and sharper. Soon, there wasn't much of a trail at all. Rocks, from pebbles to head-size and larger, had spilled down from the cliff on the right, until Wheeler was having a hard time even walking.

Then, the trail twisted again and he could see back quite a ways. It was a sobering realization. How in the hell did I get up here? He could see, far below him, the place where the motorcycle had gone over, and beyond it the main road. The true import of what he was seeing took a moment to settle in, but when it did it was like the crack of a single-tail whip. The cop was gone!

He could see the spot where the police car had been parked across the road with its blinkers flashing. Wheeler blinked and rubbed his eyes, willing it to be true. Yes, the cop was gone. They must have thought I had gotten by. Well, step one, get back to the road.

He took another sip of water. The bottle was already half empty. Just as he got to his feet, a black Ford Carryall appeared, jouncing its way up the trail below him. Wheeler's newly risen spirits crashed. He could just make out the rail of colored lights on the vehicle's roof. There could be no doubt. As if to confirm his worst fears, the vehicle stopped and a big man got out to look over the edge at the remains of the motorcycle.

He ran; in blind panic, he ran, slipping over rocks, falling, insensible to the cuts and scratches. Clutching the rifle and the water bottle, he fled.

7

John looked over the edge. There was no doubt that the Goldwing wasn't going anywhere, ever. Then, he studied the ground. Scum had left a trail a blind man on a fast horse could have followed. There were no other footprints on the ground, but even if there had been a multitude, the expensive jogging

133

shoes left an imprint that was distinctively different from anything a local would have worn.

He got back in the car and followed the tracks.

?

Wheeler's chest was heaving as he lay across a bed of rocks. Slowly, rationality returned. Running wouldn't work. He had to stop the sheriff. *I'll kill the son-of-a-bitch and take his car.* Wheeler grinned. This was more like it. He remembered a teacher at Harvard. "A good businessman is proactive, not reactive. Make people react to what you are doing, don't just react to what they do to you." The grin became more wolfish and he caressed the rifle.

He slung the rifle over his shoulder, stuffed the almost empty water bottle into one of the cargo pockets in his pants and turned toward the cliff next to the road. As he examined it, he could see that it would be relatively easy to climb. From the top, fifty or sixty feet up, he'd be in a perfect position to... *get back what is mine,* he thought.

?

For a tenderfoot, the guy's made good progress, John thought as he set the parking brake. The road had deteriorated to the point that he could make better time walking than in the Carryall. He took a Winchester .30-06 lever action from the back and dumped a box of shells into a pocket. It was only in movies where the good guy with a handgun beat out the bad guy with a rifle.

Gasping a bit from exertion, Wheeler pulled himself onto the top of the mesa. A quick sip polished off the last of the water and he threw the container to one side. *What a view,* he thought. He could see for miles. The main road was a meandering thread across the wasteland. With a shock, he noticed a cluster of vehicles at the beginning of the trail. One which looked oddly familiar was moving along the trail toward the mesa, but what really drew his eye was the sheriff's black truck about 600 yards away, just visible through a pair of rock formations. It wasn't moving. He must be on foot. *Look sharp, Kurt my boy, look sharp.* He settled himself on the edge of the mesa, his rifle at his shoulder.

Part of John's mind told him he was getting sloppy. He should be moving from rock to rock, cover to cover, but the message from Wheeler's spoor was that the guy was a complete idiot. He was running... running!... in this heat. Even the coyotes would be walking now. John shook his head. *Any minute now, I'll find him sprawled out in the middle of the trail and I can snap the cuffs on.* His first intimation of danger came when he noticed the footprints had changed direction. They had been headed straight along the trail. Abruptly they turned ninety degrees toward the nearby cliff.

Only about sixty feet away, Wheeler pulled the trigger, bracing himself for the explosion. Nothing happened. He pushed the little lever in front of the trigger and pulled it again.

Nothing! At least the sheriff was being cooperative, standing still like that looking at the ground. There was a lever on the top of the rifle. He jerked it and it came flying back at him. Wheeler was so surprised that he let go of the lever and it flew back into place with a clanking sound.

?

John heard the unmistakable sound of a round being chambered, but the echoes made it almost impossible to tell from where it had come. He dropped and rolled to a nearby rock, but no shot followed. Slowly, methodically, his eyes swept the surrounding terrain. Some movement drew his eye to the top of the cliff right above him. He brought up the Winchester and fired an experimental round into the lip of the cliff.

?

The rock in front of Wheeler exploded, spattering him with rock chips, which stung like hell. Without thinking, he raised the rifle pointed it over the cliff and pulled the trigger. To his surprise, it fired, driving the stock back into his shoulder.

In glee, he leaned out over the cliff. He could see the sheriff partially hidden behind some rocks. He pointed the rifle and pulled the trigger wildly, glorying in the noise and the feeling of omnipotence. Puffs of dust marked where each bullet struck. When Wheeler realized that, he used them as markers to walk his shots toward the sheriff, but just as he got the hang of it, his gun stopped responding to the trigger. In shock, he moved back from the edge. The lever on the top was stuck in the back position. Wheeler grabbed a rock and tried to drive it forward, but it refused to move.

Damn, John thought, the son-of-a-bitch must have stolen a case of ammo from Eva to spray it around like that. He hunkered further into shelter and lifted his head to catch a glimpse of the cliff. Frontal assaults were definitely not on the menu. He looked behind him and plotted the angle of fire from the cliff top. One more glance at the cliff top and then he quickly leopard-crawled back to better cover and then moved a hundred yards or so back to a point where the top of the cliff extended a bit out. *Once I get to the base, he can't see me and he'll have to lean way out to shoot. Getting up the last few feet might be tricky, but it's better than providing him with target practice all the way up the cliff.*

Wheeler was still riding the roller coaster of despair and elation. The failure of his rifle sent him again into a panic. There was no place to go, nowhere to hide on the small plateau, and if he tried to run, the sheriff would shoot him in the back like an animal. He decided his only chance was to kill the man when he tried to climb the cliff. He set about gathering rocks and piling them near where he was sure the sheriff would make his assault.

The climb was harder than he had expected. Cowboy boots were fine for riding either on a horse or in a car, and they weren't great for walking; but for rock climbing, they were about as useful as tits on a bull. Less: at least the tits didn't get in the way.

About halfway to the top, John slipped one more time and had to grab a protruding rock to keep from falling... but this time, his body was at just the wrong angle and the Winchester slid smoothly from his shoulder, evaded his hand as he grabbed wildly after it, bounced once on a rock and curved outward. He stared after it, willing it to land on the road where he would have a fighting chance of climbing down to recover it. Instead, with the perversity of the inanimate, it fell into a crevice. A distant clink, a few seconds later, provided ample evidence that the crevice was no shallow crack that would easily yield the gun.

Reaching down with his free hand, John made sure that the .45 was still firmly in its holster and that the safety strap was fastened. Just short of the lip, he paused and listened. Not a sound. Not that his proved anything; Scum could be just above, waiting to blow his head off as he came over the edge. Then a distant crack of rock on rock encouraged a bit of optimism. He reached over and with a heave of his shoulders pulled himself over the lip and on to the mesa's top.

It couldn't have been much better. Scum was about fifty yards to his left, with his back turned, and there was no sign of the carbine. The man was dropping a basketball-sized rock on to a small pile of similar rocks. Still, fifty yards is extreme range for a handgun, even one as well-made as Clarke's old Colt. Pulling himself to his feet, he moved as quickly as he dared toward the unsuspecting man. The top of the mesa offered no concealment whatsoever, so speed and silence were his only advantages.

They were enough. John closed the distance to about 15 yards when Scum stiffened and spun around. John immediately raised his pistol and yelled, "Don't move; put your hands behind your neck and stand still."

With widened eyes, Scum complied.

"Where's the carbine?" John demanded.

"The what?"

"Don't play dumb, the gun you were shooting at me."

Scum gestured by inclining the upper part of his body to his right. "Over there; it's broken."

John circled, placing his feet carefully. The carbine was about a foot from the edge, near the pile of rocks. *Sorry, Eva*, he thought as he kicked it over the edge. Better safe than sorry. Then, he took out his handcuffs and walked over to Scum.

7

Wheeler's consciousness was gibbering wildly in terror. He could barely stand still. The sheriff's size terrified him. He had been small in school, picked on and abused by the older, bigger boys. That was why when he had become an adult, he had worked so hard to build up his body, with years of hard work in the gym and dojo. Of course, as an adult, he had never needed to fight. Never needed to put what he had learned into practice. Now, he was a sixth grader again and the bully was coming. He could feel tears coming to his eyes. His body shook.

So his mind was a detached and somewhat amazed spectator when his arm shot out and knocked the gun aside while his whole body pivoted, leg extended to catch the sheriff on the side of the knee. He completed the maneuver by smoothly rising, straightening his arm and lancing it into the big man's solar plexus.

In amazement, Wheeler looked down as the gasping helpless man at his feet. Then, with a cry of glee, he picked up one of the rocks he had gathered and lifted it over his head to bash the life out of his tormentor.

The blow was totally unexpected. It was like a punch in the chest. Sudden weakness made him drop the rock, and when he looked down, a damp red was spreading over his shirt. The inertia of confusion held him upright for long seconds until a distant crack seemed to come from somewhere below. He looked down and the rock seemed to be rushing toward him. Blackness followed.

139

John was totally caught off guard. Scum had always been so subservient, so passive and he had looked so terrified and defeated. It all happened so rapidly that he wasn't aware of movement until the ground smashed into the back of his head and an amazing, disorienting agony filled his guts. He tried to move but couldn't as he watched Scum raise the rock. *Fuck, THIS is how it ends¿*

When the smaller man staggered, John first thought Scum had missed his footing. He tried to get up to resume the fight, but his body wasn't responding and a useless, spastic twitch was the best he could master. Then, Scum's shirt changed pattern with a growing, familiar splotch. The sound of the rifle shot followed, he guessed, six or seven seconds later.

Good men, he thought, they got their shit together in record time. Good shooting too. A sense of responsibility got him staggering to his feet to signal them he was OK. But, instead of the group of horsemen he had expected, there was only one figure standing near his Carryall. It was too far away to distinguish features, but the long red hair was unmistakable. He waved. Eva waved back.

It took almost half a hour for John to climb down to the trail. When he reached it, Eva was waiting, a heavy barreled .223 varmint rifle with a massive scope slung over her back. Her energetic greeting did nothing to assuage his various aches and pains, but was welcome nonetheless. When he got his breath back, he took a long swig from her canteen and asked, "Why¿"

Eva's dark skin flushed and she looked away. "John, I lost a good friend once." Her eyes sparkled a bit. "He was a big, dumb

lug just like you. I didn't want it to happen again." She snorted, "I don't have all that many friends."

His response was several orders of magnitude beyond what most people would classify as "friendship."

"How did you get past the road block?"

This time the blush was unmistakable. "Ah, John, don't hold it against them. I was very persuasive."

Later, as he when he encountered his mounted deputies on this way down the trail, John pointedly ignored the angry red puffiness around Peter's eye, the clear indication that he would be sporting a beautiful black eye for the next few days, and Peter didn't volunteer any information about how he came to let Eva pass the road block. Even Little John kept an uncharacteristic silence.

7

"And so it just came down to money," John said, sitting on a couch in Roissy's.

The group was silent for a moment as they struggled to digest the news. "Her brother," Clayton said wonderingly. "I hadn't even thought about him. He was kind of a black sheep of the family. I'd never met him, never even seen a picture. I wouldn't even know she had a brother except every once in a while Ruth..." He paused for a moment, eyes glittering with tears. "... Ruth mentioned that he'd written asking her for more money for some kind of harebrained scheme. The last I heard he was somewhere in India."

John nodded. "That was the word we got. Unfortunately, we didn't check with Immigration and Naturalization to see if he had returned. We just took what his office told us at face value. It was sloppy," he said, looking somewhat uncomfortable.

Eva had been sitting quietly on the couch next to him and she reached over and touched his hand. "I'll bet when you do,

you don't find anything. He may have come in on a fake passport or traveled to Canada or Mexico and just walked across the border."

"Imagine him," Shawn said, "planning this all out and living quietly here for months waiting for her to arrive." Suddenly, he snapped his fingers. "The mask! It was just so she wouldn't recognize him. That's why he took it off after she died."

Kevin looked at his partner with compassion and swatted him playfully. "That's what I love about you, your stunning grasp of the obvious. As if there was anyone else in this room who hadn't figured it out five minutes ago."

Shawn took on an innocent look and said, "Like someone who couldn't tell the difference between a Midnight Cowboy and a cowboy at midnight?"

Kevin flushed and then looked sheepish. He swatted Shawn again and said in a mock threatening tone, "You're going to be sorry tonight for bringing that up."

Sara broke into the exchange with "Well, I don't know about anyone else but I'm just glad to have this settled. I really didn't enjoy being a murder suspect."

Her husband took both of her hands in his and said, "Darling, I'm sure the Sheriff didn't think you killed Ruth." He glanced at John, who kept his face blank, and then added, "If there was a suspect I have a feeling I was it." He looked at John again. "Isn't that right, Sheriff?"

John started to speak, but Eva cut him off. "Let's face it. In this case, we were all suspects." Then she smiled to take the sting off the pronouncement. "But it's all over now."

"All over." The words were a croak, involuntarily coming forth. All eyes turned on George. "All over," he repeated and then put his head in his hands and started to sob. There was a few moments of embarrassed silence and simultaneously Sue and Sara got up and went over to the crying man. Sue sank to her knees at his feet taking his hands in hers and Sara bent over

and hugged him. The remaining members of the group looked at each other with embarrassment and sat silently.

Finally, Sara and Sue helped George to his feet and out of the room. John looked at the remaining guests and rose to his feet. "If you'll excuse us, gentlemen, Eva and I have a few details we have to go over." He held out a hand to help her to her feet and they left the room.

Back in her office, the two settled down, and Eva poured them each a stiff shot of Scotch from a bottle she took out of a cabinet.

"There'll have to be a hearing," John said.

"I've been thinking about that," she replied. "Do you think there will be much of a fuss?"

John slowly shook his head. "We had a murder suspect about to commit bodily harm..."

Eva interrupted him with a snort. "That 'bodily harm' would have splattered your brains all over the county."

John gave an abrupt laugh, almost a bark. "Yeah, but that's the way the report will get written up. You know the style, macho cop. Anyway we had a murder suspect about to commit bodily harm and a duly sworn deputy took proper action. You know the drill."

"Sworn deputy?" Eva said, puzzled.

John took something from his pocket and scaled it over to her desk. The eight pointed gold star spun for a few seconds on the polished surface before coming to rest. "Guess with all the excitement, you forgot; when this all got started, I swore you in as my representative out here."

Eva stared at him, revelation dawning.

He continued. "All the paperwork is on file in my office." He grinned. "At least, it will be on file as soon as I get back to the office."

"Is this really necessary?" she asked. "After all, this isn't New York, and it was a righteous shoot."

John's smile faded. "If it was anyone else, I wouldn't think twice about this, but you've got some enemies around town."

143

He thought of telling her about Councilman Rosario, but dismissed it. "As a private citizen, your case would be decided by the local DA. But with a cop shoot, the state police have jurisdiction on the investigation."

He laughed. "The idea is that local authorities might cover up a bad shoot by a local cop and the Staties would be more impartial, but it will work just as well for us this way." He gave another laugh. "Besides, you got the town on the hook for $15." Eva looked at him quizzically. "The job pays five bucks a day," he responded to her unspoken question.

"Seriously, Eva, you saved my ass out there, and I appreciate it. You were pretty quiet on the ride back...¿" He left the question hanging in the air.

For a long moment silence was a tangible pressure around them. Then, Eva spoke. "It was the first time," she said, looking up, her eyes dark and troubled. John waited, silently. "There were guys back in New York, guys I wanted to kill. I really hated their guts, but I never had to pull the trigger." She looked down and then lifted her head and looked at him, but he could see that her eyes were focused somewhere else. "I could have. At least, I think I could have. I even think I might have enjoyed it, but Scum... Don't get me wrong; what he did was awful, and what he was going to do to you was worse, but I hadn't had the time to work up a proper hate." Her eyes refocused and he could see she was back in the room with him. "If I could hate him, it would make it a lot easier now."

John spoke quietly, so softly she could barely hear him. "You aren't supposed to hate. You're just supposed to do a job. You do, of course, anyway. You're human. I know what you mean, Eva. But you did it just right, only what you had to do and not one thing more. If you had hated him, you'd feel better right now, but later, you'd wonder... and you'd spend the rest of your life wondering if it really was what you had to do or if it was what you wanted to do. That eats at you, Eva; it eats at you."

144

Eva's eyes widened as she recognized the haunted look in his eyes. Two pairs of hands reached out for each other. It was Eva who got out of her chair and into John's. The hug went on for a long time.

"Ever wonder why we never got together?" John said softly.

Eva's voice was muffled by his shirt. "I guess when I got here the time wasn't right. I was still shook up from how my last investigation had turned out." She looked up a him. "It had cost me one boyfriend. I guess I wasn't ready to take another chance." Then her voice firmed up a bit. "And you were still mourning your wife. The auto accident had been only six months or so before I got here."

John's eyes got distant and a bit glistening. Then, he refocused at the woman in his arms. "True, I was still sort of running on autopilot then."

"Besides," Eva interjected with a laugh, "I like to spank men. You aren't into that."

John laughed. "And I thought you were a good judge of character..."

7

When Eva returned to the rec room, Sue, Sara and Clayton were already back. All three had eyes still raw from shed tears but the mood was considerably lighter. Sue had her tarot cards out and was building a cross. Clayton was sitting across the table from her while the others watched.

She had already put down three forming a vertical line, a running man with a sword, a flutist, and a upside-down man with an odd hat and seven golden coins floating around him. Under them, she continued the line, snapping each card down with an experienced hand. A man in a swan-shaped boat with six swords. A dead man with ten swords in his back. A blind-folded woman holding two swords. A naked woman rising

145

from a flaming cauldron in front of a blazing phoenix. Two cards went down flanking the second from the top, a naked woman pouring something from a black and a clear bowl and an upside-down queenlike character holding a staff. Finally, a lute-playing man in a chariot drawn by a black and a white horse went over the flutist.

Sue looked at the pattern, running her hand through her long hair. Then she looked up at Clayton and smiled. "This is good, very good. The only really bad card is the ten of swords." She touched the one with the dead man and shuddered.

"That was in..." Tom said and fell silent.

Sue nodded and looked at Clayton. "I did a reading for Raven."

"She told me," he said flatly.

"But this is different. In this position, it isn't showing us the future. It's about your emotions. You are desolate; you feel like things are an utter disaster."

He nodded.

"But look at this." She touched the top card. "This is the Page of Swords. It signifies the future. It's all about insight and service... maybe a service done in secret." Then she touched the bottom card in the line. "This is about your major influence. There's trouble and problems."

Clayton gave a barking laugh.

"But they are falling behind you. Things should get better."

She lifted the lute playing man and touched the card under it. "This one puzzles me. It's The Fool. In this position it represents your present situation and usually means light-hearted innocence.

Clayton shrugged. "I certainly don't feel either light-hearted or innocent."

Sue put back the lute-playing man and touched the next card in the line. "This is the Seven of Pentangles. Here, it's telling us about your recent past. Conventionally, it's about money lost or anxiety about money, but I wonder. People can

146

have anxiety about money that has nothing to do with the lack of it. Maybe you were concerned about how Raven made her fortune?"

Clayton looked at her, tilted his head sideways, opened his mouth and then closed it, motioning for her to continue.

Sue touched the card forming the left arm of the cross. "This is the Star. In this position, it shows the near future." She smiled. "It's very positive. It shows a hope for the future, the best of the past with the present."

She touched the inverted card making up the right arm. "This shows us recent events." She frowned. "It's the Queen of Wands, a woman of considerable passions, one who even might have been overruled by passions."

No one spoke or moved.

She touched the fourth card in the vertical line. "This is hopes and fears. The two of swords implies sorrow and grief, the ending of a relationship."

Quickly, she touched the bottom, the naked woman. "This is very good. This shows the major influence and it implies that your troubles are going to fall behind you."

Sue looked around. "Considering what we've all been through, I'd say this was a pretty good reading."

Clayton was staring at the cards. Then he shook himself, put his hands on the table and stood up. "I've been giving this a lot of thought," he said. He gave a wry laugh. "When I wasn't wondering when the Sheriff was going to haul me off."

He looked around. "Where is he? I want to thank him." Before Eva could respond, Shawn doubled over with laughter. Suddenly the center of somewhat disapproving attention, he struggled for control, only to fall back into an upholstered chair with redoubled laughter. Finally, Kevin picked up an unread copy of the Wall Street Journal still in its rolled wrapper and swatted his partner.

"What in the fuck is so funny?" he said peevishly.

Shawn got control of himself long enough to gasp something inarticulate followed by "Silver."

Clayton was the first one to get it. He gave a quick laugh and with a sheepish expression he said, "God, it does fit."

Eva was still in the dark. "What is going on?" she said with a hint of exasperation.

This time, Shawn's gasped "Hiho, Silver" was clearly recognizable.

Tom laughed, "Yup, they always ended the show with someone saying, "Who was that masked man? I never had the chance to thank him."

Eva joined in the laughter for a moment and then said, "He had to leave. There's a lot of paperwork in something like this, but I think he'll be back before you all leave on Saturday."

"I think I'll be leaving sooner than that," Clayton said, and the air of tension-generated levity vanished, leaving only a feeling of group embarrassment. Clayton sensed the change and said, "Don't be concerned. I'm all right. I'll be grieving for Ruth for a long time, but there is a lot of work to be done, and it will help."

"I've also got to make a few changes." He looked at Sue. "I've been thinking of how things have been going and what I should do, but it was your card reading that really crystallized things."

He turned to Sara and George. "Ruth didn't do right by you. I can't undo all of what she's done. After all, I have to answer to stockholders and the board of directors, but I'm going to do my best to see that things get set right again." While Sara and George looked at him dumbfoundedly, he went on. "If you accept it, George, I'd like to have you back as president of Virtuality. I won't have any trouble with the Cabot guy Ruth put in charge; he's just a flunky. I can move him to some other company where he'll be perfectly happy.

"You won't be the owner. You'll be an employee, but we're talking six figure income, stock options, profit sharing, all the perks." He held out his hand.

George took it while Sara squealed with joy.

148

Other Books from Greenery Press & Grass Stain Press

Bitch Goddess: The Spiritual Path of the Dominant Woman
edited by Pat Califia and Drew Campbell — $15.95

The Bottoming Book: Or, How To Get Terrible Things Done To You By Wonderful People
Dossie Easton & Catherine A. Liszt, illustrated by Fish — $11.95

Bottom Lines: Poems of Warmth and Impact
H. Andrew Swinburne, illustrated by Donna Barr — $9.95

The Compleat Spanker
Lady Green — $11.95

The Ethical Slut: A Guide to Infinite Sexual Possibilities
Dossie Easton & Catherine A. Liszt — $15.95

A Hand in the Bush: The Fine Art of Vaginal Fisting
Deborah Addington — $11.95

Juice: Electricity for Pleasure and Pain
"Uncle Abdul" — $11.95

KinkyCrafts: 99 Do-It-Yourself S/M Toys
compiled and edited by Lady Green with Jaymes Easton — $15.95

Miss Abernathy's Concise Slave Training Manual
Christina Abernathy — $11.95

Sex Toy Tricks: More than 125 Ways to Accessorize Good Sex
Jay Wiseman — $11.95

SM 101: A Realistic Introduction
Jay Wiseman — $24.95

Supermarket Tricks: More than 125 Ways to Improvise Good Sex
Jay Wiseman — $11.95

The Topping Book: Or, Getting Good At Being Bad
Dossie Easton & Catherine A. Liszt, illustrated by Fish — $11.95

Tricks: More than 125 Ways to Make Good Sex Better
Jay Wiseman — $11.95

Tricks 2: Another 125 Ways to Make Good Sex Better
Jay Wiseman — $11.95

Coming In 1999

Jay Wiseman's Erotic Bondage Handbook, by Jay Wiseman
Blood Bound: Guidance for the Responsible Vampire, by Deborah Addington & Vincent Dior
Sex-Positive Health Care: A Manifesto & Consumer Guide, by Charles Moser, Ph.D., M.D.
Haughty Spirit, by Sharon Green
Justice and Other Short Erotic Tales, by TammyJo Eckhart

Please include $3 for first book and $1 for each additional book with your order to cover shipping and handling costs. VISA/MC accepted. Order from:

3739 Balboa #195, San Francisco, CA 94121
toll-free: 888/944-4434 fax: 415/242-4409 http://www.bigrock.com/~greenery